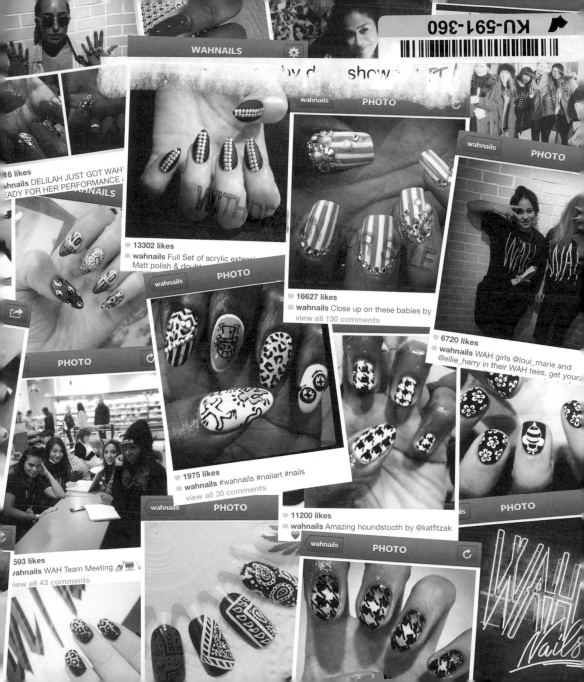

WAHNAILS

wahnails PHOTO

16 likes
wahnails DELILAH JUST GOT WAH'
READY FOR HER PERFORMANCE A
WAHNAILS

13302 likes
wahnails Full Set of acrylic extensi
Matt polish & doubl

16627 likes
wahnails Close up on these babies by
view all 130 comments

wahnails PHOTO

6720 likes
wahnails WAH girls @loui_marie and
@ellie_harry in their WAH tees, get your.

PHOTO

wahnails PHOTO

1975 likes
wahnails #wahnails #nailart #nails
view all 30 comments

PHOTO

wahnails PHOTO

11200 likes
wahnails Amazing houndstooth by @katfitzak

593 likes
wahnails WAH Team Meeting
view all 43 comments

wahnails PHOTO

THE WAH NAILS **BOOK OF DOWNTOWN GIRLS**

SHARMADEAN REID

THE
WAH
NAILS
BOOK
OF
DOWNTOWN
GIRLS

SHARMADEAN REID

hardie grant books
MELBOURNE · LONDON

CONTENTS

HELLO!

When I started WAH Nails in early 2009, I knew it would be successful, but I never anticipated just how crazy it would be. This month alone we have painted nails in New York, Paris, Hong Kong and Shanghai. We've been on TV, on radio and in just about every newspaper and magazine. We've painted nails at festivals and fashion weeks, for pop starlets and actresses. And we brought out the first book, *The WAH Nails Book of Nail Art*. But what I feel is our greatest achievement is spreading nail art culture globally so that it's now the norm to have cool designs on your nails. Nail artists and salons all over the world have been taking nail art to the next level by putting their own unique twist and spin on it, raising the game and encouraging a whole new generation of artists to pick up their polish brushes and get practising!

The tutorials in this book have been chosen to show a variety of styles and designs that are popular in our London salon, but what's most exciting is seeing what style of nails are popular all around the world! For the first time, we are highlighting our favourite nail artists in key cities internationally. These are the girls who have been setting trends in their hometowns and expanding their love of nails to other outlets. We also meet 'zine-makers, film makers and polish manufacturers who have all used nails as their inspiration and motivation to turn their passions into their professions. The thing I get asked most is how I started Wah Nails. I hope to answer this question and others on careers and business by gathering the experiences of my friends and like-minded people, and to inspire you to start your own projects.

You see, WAH Nails is more than just a salon — to me, it's a state of mind. We often joke amongst my friends and staff, that something is 'not very WAH'* — like allowing someone to walk all over you is not very WAH, or not having the confidence to get the job you want is not very WAH, or even having a bad hair day is not very WAH! It represents a certain value and self-respect, originating from my own feminist ideals, that gave me the confidence to open the salon, stand for what I believe in and stick to my guns. Along the years, I've been fortunate to meet other women like this and I refer to them as 'Downtown Girls Worldwide' — our friends, family, BFF's who all have the downtown vibe and WAH way of life. It doesn't matter where you live geographically! If you've got great style, street sassiness and the right amount of attitude, you're a Downtown Girl. I hope this WAH mentality, along with bits of advice from my friends, will help you kickstart your own thing, whether you want to become a nail artist, write your own book, or start your own business. It's all out there for you. Go get it!

*Sometimes we say #expensive instead of WAH. Like, those hood nails you got from some random salon down the street are not very #expensive...

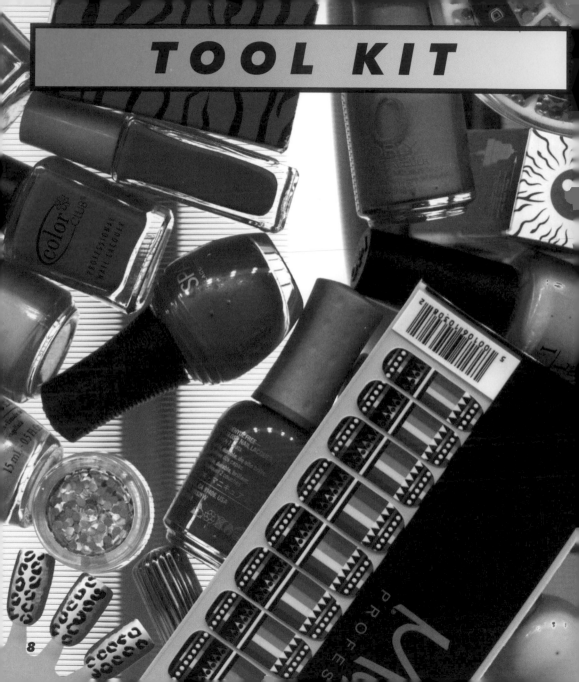

TOOL KIT

Depending on how professional you want to get, your nail kit can be as little as a few polishes, pens and stripers, to a huge case packed with all kinds of nail equipment and goodies! This list covers most of the things that you need to do the designs in this book, although not all are essential. You can do a lot with one polish colour and one nail art pen. The thing we absolutely recommend is a good topcoat. After all your hard work on your nail art, you dont want it ruined by a cheap gloss. If there is one bit of your kit that you spend money on, make sure this is it as a good topcoat will give any cheap polish a smooth, glassy finish.

Trawl the internet, eBay and craft shops for small, fun things to stick on your nails. As long as they are small and flat, it will work. If it's too flat, for example, a metal loveheart, try curving it with pliers so it fits around your nails. If you want a truly personal design, you can also make your own nail art accessories with 3D acrylic and decals!

01 - HAND SANITIZER
Ensure you use hand sanitiser before starting work, in case of any nasty cuts. A non-alcohol based gel or spray will stop your hands drying out.

02 - NAIL FILE
The higher the grit number, the smoother it will be. Get a good quality one that you can wash and reuse.

03 - WHITE BLOCK BUFFER
Important for smoothing over the nail but also creating an ideal surface for your polish to stick to.

04 - SHINE BUFFER
If you're going to have your natural base exposed in your design, shine it up!

05 - CUTICLE PUSHER
For lifting the cuticle on the nail plate. Not for pushing back your skin!

06 - CUTICLE NIPPER
Using them sparingly to cut your cuticles after you've lifted. Beware of cutting your live skin, which frames your nail.

07 - BASE COAT
To help your nail polish stick and protect your nails from staining.

08 - NAIL POLISH COLOURS
You should know what these are by now...

09 - TOP COAT
Totally important for sealing your nail art and adding that glossy finish!

10 - CUTICLE OIL
Essential for combating dryness around the nail that you get from polish remover and keeping your nail bed nourished.

11 - NAIL POLISH REMOVER / ACETONE
For cleaning up your nail design and removing your nail polish or old gel and acrylics.

12 - NAIL ART PEN
Without these we would not exist — there is so much possibility with a nail pen! Start with black then build your colour collection.

13 - NAIL STRIPERS
Use these for straight lines. To keep your bristles neat, snip any loose hairs with small scissors. If the brush starts to bend, bin it!

14 - EMPTY NAIL STRIPER
Keep an empty bottle filled with polish remover and wipe after each use. Dip into your chosen polish when needed.

15 - SPONGE
Make-up ones are ok, but dishwashing sponges with large holes are great for fades.

16 - TWEEZERS
For applying decals and jewels.

17 - DECAL PAPER
Print your own designs with these.

18 - FIMO CANES
Small canes, usually of fruit or animals, can be sliced really thinly and applied to the nail for decoration.

19 - NAIL WHEEL
Practice your designs on blank nail wheels.

20 - CLEAN-UP BRUSH
An old make-up brush will do. Make sure bristles are short and don't rot in the polish remover.

21 - NAIL JEWELLERY
Great for blinging up your nail. Curve it with pliers for a longer lasting finish.

22 - SWAROVSKI CRYSTALS
Cheap rhinestones don't cut it in our book. If you want proper bling go for crystals!

23 - ORANGE STICK/COCKTAIL STICK
Great for creating swirls and marbling but also for picking up nail studs and jewels.

24 - HAND MOISTURISER
The more you do nails, the drier your hands get from the constant chemical exposure. Keep your hands moisturised!

25 - NAIL GLUE
Use small amounts to stick on any heavy nail accesories.

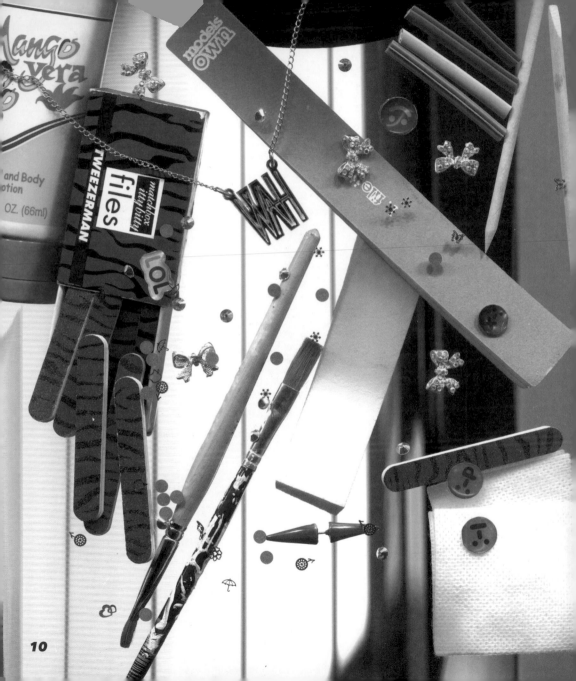

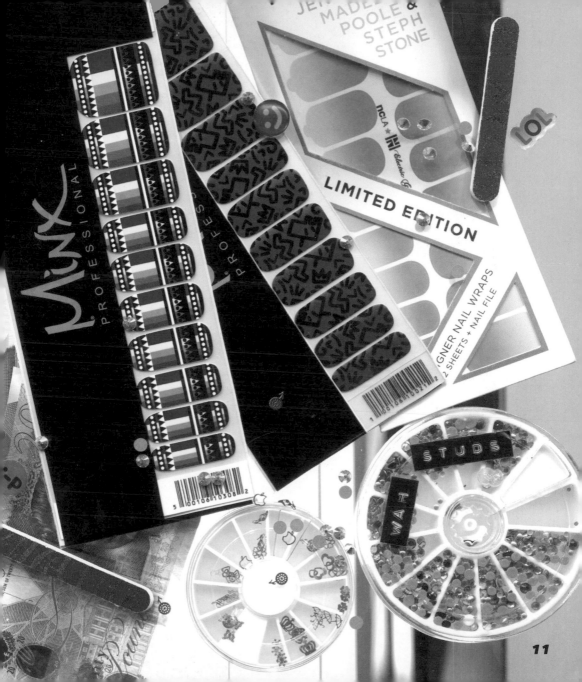

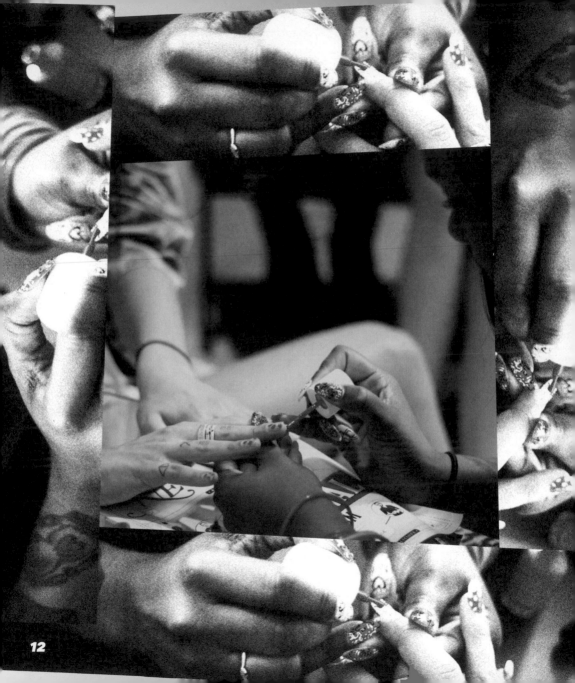

PREP & FINISH

PREPPING YOUR NAILS PROPERLY ENSURES THAT YOUR NAIL POLISH STAYS ON FOR AS LONG AS POSSIBLE! FOLLOW THESE STEPS FOR A PROFESSIONAL FINISH.

PREP

STEP 1 — Before you begin painting, it's crucial to prepare a clean base. Take a lint-free nail wipe and soak it in nail polish remover. Place it over your nail for a few seconds and then pinch in from the sides and sweep down the nail.

STEP 2 — File your nails to the shape you want. Even if you've filed them recently, you may have knocked your nails and caused uneven tips. File using smooth, long motions towards the centre of the nail, from the sides in. Don't file furiously backwards and forwards like you're using a saw because you'll damage your nails. Make sure they're all the same length.

STEP 3 — Using a buffer, buff your nails lightly to create a smooth nail bed. Buffing will also get rid of any ridges. Only buff once a week.

STEP 4 — It's important to dehydrate the nail before you apply the base coat — this will really make the polish stick. Use a lint-free nail wipe soaked in nail polish remover to get rid of any excess oil moisture or dust from buffing. Don't touch your nail bed as the moisture from your fingertips will prevent polish from staying on.

STEP 5 — Now you're ready to use your base coat! Apply a thin layer of base coat to each nail and leave to dry for one to two minutes. All that's left to do now is to choose your nail design!

FINISH

STEP 1 - Once you've finished your nail art or design, wait for five minutes to apply your top coat so you don't smudge your work! Use Seche Vite top coat (WAH's fave), and apply a generous layer to the nails. Make sure your brush isn't overloaded with polish — you can remove any excess by wiping it across the neck of the polish bottle.

STEP 2 - To perfect your work, always have a small, clean-up brush to get rid of any imperfections. Dip your brush in acetone or nail polish remover and sweep around the cuticle area for a really neat line of polish around the base of your finger.

STEP 3 - To get rid of dry cuticles, apply a swipe of cuticle oil around them. This hydrates the area around the cuticle and leaves a nice, neat, shiny finish.

13

NAIL ART TOOLS

THERE ARE TWO KEY THINGS YOU NEED TO DO THE NAIL ART IN THIS BOOK: A NAIL ART PEN AND NAIL ART STRIPER, BOTH WIDELY AVAILABLE ONLINE OR AT YOUR LOCAL NAIL SUPPLY STORE. EXPERIMENT WITH DIFFERENT SIZES AND BRANDS TO FIND WHAT WORKS FOR YOU!

TIPS AND TRICKS

NAIL ART PENS ARE PENS FILLED WITH NAIL VARNISH THAT YOU SQUEEZE OUT OF A TINY NIB TO DRAW SHAPES AND PATTERNS ON YOUR NAIL.

SOME OF THEM ALSO CONTAIN STRIPERS INSIDE IF YOU SCREW OFF THE NIB!

YOUR NAIL ART PEN IS YOUR ULTIMATE TOOL SO LOOK AFTER IT. WIPE THE NIB AFTER EACH USE TO ENSURE IT DOESN'T GET BLOCKED.

IF IT DOES GET BLOCKED, SIT THE NIB IN THE TINIEST POOL OF POLISH REMOVER FOR A FEW HOURS TO LET IS DISINTERGRATE THE BLOCKAGE.

IF IT RUNS OUT YOU CAN REFILL IT BY SCREWING OFF THE NIB AND POURING FRESH POLISH OF THE SAME COLOUR INSIDE YOUR PEN.

SQUEEZE YOUR NAIL PEN OUT A TINY BIT ON A SURFACE JUST BEFORE YOU START PAINTING. THIS IS TO GET RID OF ANY AIR BUBBLES, OTHERWISE YOU MAY SPLAT A LOAD OF VARNISH ON YOUR PRISTINE NAIL. SOME OF THE GIRLS IN THE SALON USE THEIR HAND!

FOR TINY DOTS AND DETAILED WORK, DONT SQUEEZE THE PEN ACTUALLY ON THE NAIL. INSTEAD, LET A TINY BALL OF POLISH FORM ON YOUR NIB AND THEN STROKE IT ON THE NAIL IN YOUR DESIRED SHAPE. THIS PREVENTS LARGE BLOBS OF POLISH RUINING YOUR DESIGN.

PRACTISE PRATISE PRACTISE! CONTROLLING YOUR NAIL ART PEN MAY SEEM TOUGH AT FIRST BUT EVERYONE GETS BETTER WITH PRACTISE.

KEEP YOUR NAIL PENS COOL! WHEN THEY HEAT UP THE VARNISH INSIDE EXPANDS AND FLOWS OT OFT HE NIB TOO QUICKLY MAKING IT DIFFICULT TO CONTROL. TRY KEEPING THEM IN THE FRIDGE ON A HOT DAY.

YOUR POLISH STRIPER CAN BE A LITTLE MORE UNRULY. BEFORE YOU BUY IT OPEN THE CAP AND CHECK THAT THE BRISTLES ARE POKER STRAIGHT. LIMP BRISTLES ARE UNUSABLE.

WE RECOMMEND ALSO BUYING AN EMPTY STRIPER BOTTLE. FILL IT WITH VARNISH REMOVER AND THEN YOU CAN DIP IT IN ANY NAIL VARNISH COLOUR TO COMPLETE YOUR DESIGN. AFTER USING IT WITH A NEW COLOUR, WIPE THE BRISTLES WITH A LINT-FREE PAD SOAKED IN VARNISH REMOVER AND THEN DIP IN BACK INTO ITS BOTTLE.

WIPE THE CAP AFTER YOUR STRIPER WITH EACH USE - YOU SHOULD BE DOING THIS WITH ALL YOUR NAIL VARNISHES ANYWAY! A CRUSTY CAP ALLOWS AIR TO GET TO THE POLISH WHICH MAKES IT THICKER AND EVENTUALLY UNUSABLE.

WHEN PAINITING STRAIGHT LINES, WIPE ANY EXCESS VARNISH INTO THE LID OF YOUR STRIPER AND THEN INSTEAD OF USING THE TIP TO DRAG THE VARNISH ALONG THE NAIL, LAY THE BRUSH ON THE NAIL AT A FLATTER ANGLE SO YOU ALREADY HAVE HALF OF YOUR LINE DRAWN. THEN COMPLETE BY DRAGGING OFF THE NAIL.

IF YOU FIND YOU HAVE ANY LOOSE BRISTLES, WIPE THE BRUSH CLEAN AND THEN SNIP THEM OFF IMMEDIATLEY. THEY CAN RUIN YOUR PERFECT DESIGN.

KEEP YOUR TOOLS NICE AND CLEAN. NOT ONLY IS THIS GOOD FOR HYGIENE, BUT IT ALSO ENSURES YOUR KIT LASTS A LONG TIME!

A NOTE ON THE FLOATING TECHNIQUE: It's important to wait a while to let your nail art settle before applying the topcoat, otherwise you may end up dragging your design and smudging it. But if you really can't bear to wait, we use the floating tehcnique to apply your topcoat onto semi-wet nail designs. Apply a generous blob of polish over the wettest part of your design. Wait a nanosecond and then using your topcoat polish brush, waft or float the topcoat over the nail rather than dragging it in long stripes. You can also just dot blobs of topcoat over parts of your design and then continue topcoating as usual.

NAILCARE 101

MARIAN NEWMAN IS MY FAIRY NAILMOTHER. WHEN I WAS A MERE TEENAGER BUYING COPIES OF VOGUE WITH MY POCKET MONEY IT WAS HER WORK FOR BRANDS SUCH AS DIOR, PHOTOGRAPHERS NICK KNIGHT AND ON SUPERMODELS LIKE KATE MOSS, THAT INSPIRED ME TO PAINT MY NAILS CONSTANTLY, (DESPITE HAVING TO TAKE IT OFF THE NEXT DAY FOR SCHOOL). SHE'S WORKED WITH PRETTY MUCH EVERY NOTABLE DESIGNER TO CREATE ARTISTIC, INCREDIBLE NAILS THAT TAKE THE INDUSTRY TO THE NEXT LEVEL. FORMERLY A FORENSIC SCIENTIST (!) SHE HAS BEEN A NAIL TECHNICIAN FOR OVER TWENTY YEARS AND IS THE AUTHOR OF THE ULTIMATE MANUAL, THE COMPLETE NAIL TECHNICIAN, FOR THOSE WHO WANT TO GET INTO NAILS. GO BUY IT NOW! WHAT SHE DOESN'T KNOW ABOUT NAILS ISN'T WORTH KNOWING, SO WE DECIDED TO CHALLENGE HER WITH THE MOST COMMONLY ASKED QUESTIONS WE GET IN THE SALON. AUNTY MARIAN, WHATS THE LOWDOWN ON MY NAIL PROBEMS!?

DEAR AUNTY MARIAN, WHY DO MY NAILS FLAKE OFF AND PEEL? IT LOOKS AWFUL, WHAT CAN I DO?

It's a dryness in your nails. Keep them short for now; remove the edge with a fine file every week (like trimming split ends on your hair); keep them covered with polish, reapplying every 2-3 days — even clear — to protect them from water which is the worst chemical for nails. Use a good nail oil every day.

DEAR AUNTY MARIAN, WHATS BETTER ACRYLIC OR GEL?

No difference! They are both acrylics. It's in the application and the removal that makes the difference. Have a fabulous nail technician who understands their profession! What is seriously BAD is a liquid and powder that is an MMA as this needs major etching of the nail to make it work! If a technician uses a 'drill' on your own nail than they are probably using MMA. Good acrylics do very little, if any, damage to your nail.

DEAR AUNTY MARIAN,
DO ACRYLICS REALLY RUIN YOUR NAILS?

NO! They can do — just like bleach can damage your hair — but a good nail technician, who knows what they are doing (using modern products and techniques), will not damage your nails!

DEAR AUNTY MARIAN,
WHAT ARE THOSE LITTLE WHITE FLECKS ON MY NAILS

Well that depends. The occasional white fleck is like a bruise on the nail and will grow out. Loads of white flecks 'may' mean a mineral deficiency but there will be other symptoms, not just white spots on the nails. Seen after removal of gel polish or nail enhancements mean improper removal!

DEAR AUNTY MARIAN,
MY NAILS ARE REALLY RIDGED. WHY? AND
WHAT CAN I DO ABOUT IT?

Very little. It may be a temporary damage to the place where the nail grows and will, eventually, grow out. It could be permanent damage to that area (under the skin at the base of the nail) and will always be there. It could also be a hormonal change (usually due to age). Ridges should NOT be buffed out as this will thin the nail and cause other problems. The best solution is to use a ridge filler or a gel polish to smooth them out.

DEAR AUNTY MARIAN,
I BITE MY NAILS. WHATS THE BEST WAY TO STOP?!

Tricky! How does a smoker stop smoking? With difficulty and discipline. Regular manicures really do help! Painted nails definitely do deter biting. A manicurist/technician can make bitten nails look so much better and that will deter the odd bite!!

DEAR AUNTY MARIAN,
MY NAILS ARE YELLOW!!! WHY AND WHAT SHOULD I DO?

This is usually due to polish staining (or smoking!). If smoking isn't the issue then use a buffer to, gently, remove the staining then always use a base coat to prevent the coloured polish from staining

DEAR AUNTY MARIAN,
I'VE GOT A HANGNAIL!!1 ITS KILLING ME! WHAT DO I DO?

A hangnail is a spike that sometimes appears down the side of the nail. Do NOT pull it or bite it!!! This will cause it to be painful and probably result in an infection. Use a clean pair of cuticle nippers and snip it off without pulling. If it has already got to the painful stage keep it clean, even soak it in a salt solution or apply a disinfectant cream like Savlon.

DEAR AUNTY MARIAN,
WHERE IS MY ACTUAL CUTICLE?!?!

Your real cuticle is a very thin layer of dead skin cells that sits on the base of your nail. It is NOT the skin that frames your nail! The frame of your nail is living skin the must NEVER be cut! If it's cut it will form scar tissue and get thicker. The living skin should be kept moisturised and massaging a good nail oil will help this. Cuticle removal products will soften the real cuticle and this can be rubbed off with a towel or an orange stick.

17

Sometimes we joke that a bad leopard print design can often look like bacteria. Then one day we were like, but let's actually do bacteria nails! Our super intern-turned-employee Ellie came up with this design influenced by the incredible art photographer Fabian Oefner, who captures weird scientific phenomena under microscopic lenses and makes it beautiful and pretty. This one can be a little time consuming but the effects are so ridiculously good its defo worth the wait!

STEP 1
Pick your polishes. I recommend neons! Paint a single, thin white base followed by two coats of neon yellow.

STEP 2
Using your choice of polish colours, dab a generous amount onto the nail in spots and blobby shapes. Do this for all of the colours.

YOU WILL NEED
· 7 different coloured neon polishes
· cocktail stick
· black nail art pen

BACTERIA

STEP 3
While the polish is still wet, use a cocktail stick to swirl and blend the polish together where they meet. This will make new colours.

STEP 5
Top-coat using the floating technique so that you don't smear your handiwork.

STEP 4
After this has had a couple of minutes to dry, grab your nail art pen and outline each colour. Try to keep it very round and almost blob like — mix up your shapes!

TOP TIP
USING A WHITE BASE WILL MAKE YOUR COLOURS POP! DON'T SKIP THIS PART.

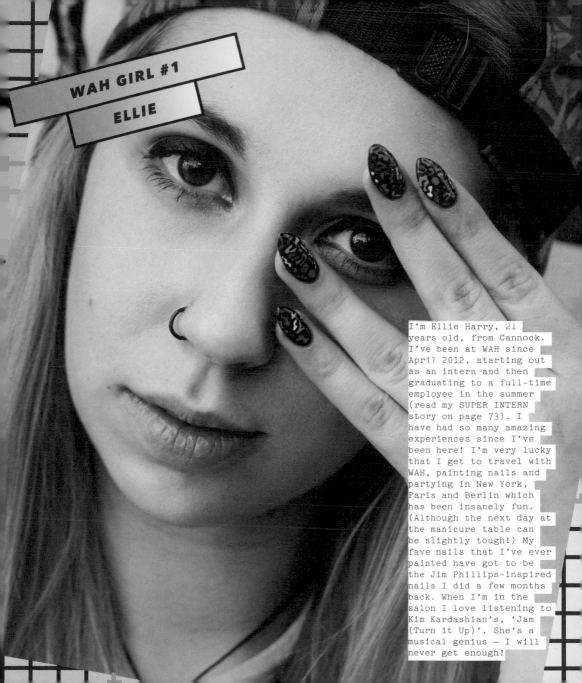

I'm Ellie Harry, 21 years old, from Cannock. I've been at WAH since April 2012, starting out as an intern and then graduating to a full-time employee in the summer (read my SUPER INTERN story on page 73). I have had so many amazing experiences since I've been here! I'm very lucky that I get to travel with WAH, painting nails and partying in New York, Paris and Berlin which has been insanely fun. (Although the next day at the manicure table can be slightly tough!) My fave nails that I've ever painted have got to be the Jim Phillips-inspired nails I did a few months back. When I'm in the salon I love listening to Kim Kardashian's, 'Jam (Turn it Up)'. She's a musical genius — I will never get enough!

THESE THINGS I KNOW

PIA ARROBIO IS HEAD OF SALES AND MARKETING AT REFORMATION CLOTHING, WHICH IS, WITHOUT A DOUBT THE BEST ECO LABEL AROUND RIGHT NOW, WHERE THE CLOTHES ARE AS HOT AS THE TEAM BEHIND THEM. BASED IN LA, BUT WITH NEW YORK AT HER CORE, PIA IS ONE OF THE GIRLS YOU WANA HANG OUT WITH AND ALL THE BOYS WANNA BE WITH - A DOWNTOWN GIRL FOR EVA. WE SPOKE TO HER ABOUT HER LIFE MOTTOS AND WHY HOLDING YOUR OWN IS AS IMPORTANT AS LOOKING FRESH!

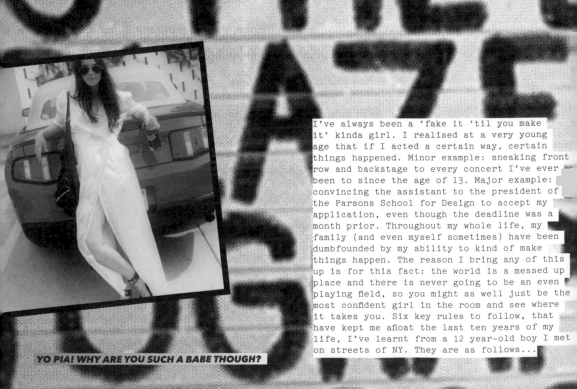

YO PIA! WHY ARE YOU SUCH A BABE THOUGH?

I've always been a 'fake it 'til you make it' kinda girl. I realised at a very young age that if I acted a certain way, certain things happened. Minor example: sneaking front row and backstage to every concert I've ever been to since the age of 13. Major example: convincing the assistant to the president of the Parsons School for Design to accept my application, even though the deadline was a month prior. Throughout my whole life, my family (and even myself sometimes) have been dumbfounded by my ability to kind of make things happen. The reason I bring any of this up is for this fact: the world is a messed up place and there is never going to be an even playing field, so you might as well just be the most confident girl in the room and see where it takes you. Six key rules to follow, that have kept me afloat the last ten years of my life, I've learnt from a 12 year-old boy I met on streets of NY. They are as follows...

1. **Get money:** Work as a waitress, sell your clothes online, start a service with cute delivery girls (yes I've done all three). There are a million ways to make money and its impotant you learn to do it on your own as soon as possible.

2. **Don't back down from what you want:** If you're going to start something you'd better finish it. Don't give up trying. It will be tough along the way but a good struggle is humbling and very important for human growth.

3. **Look fresh:** DING DING DING! Everybody's gotta look fresh!

4. **'Mind your business'** - Being all up in everyones business is a bad look. I know this because I used to do it all the time. Nothing good comes from knowing too much about other people. If you focus on your own lane you won't crash into someone else's.

5. **Don't snitch:** Snitches get stitches.

6. **Hold your own:** I love 'holding my own'. It's basically just me being the most Pia I can be at all times. The trick to this is confidence. I'm the most insecure, overly confident person I know! Fake it 'til you make it baby! Confidence is the ultimate game changer and the single most important quality I look for in the women in my life.

Every now and then, we all wanna unleash the Chola inside of us and what better way to do this than with some gold hoops, a bit of lip liner and bad-boy bandana nails. These babies take influence from the motifs on our Paisley design (page 86), and with the right colour palette and mix of pattern, you too can make authentic bandana looking nails.

STEP 1
Paint your base colour. Black works really well as does white and other traditional bandana colours. Begin with your teardrop and four-star motifs.

YOU WILL NEED:
· black polish
· white striper
· white nail art pen

STEP 2
Outline each motif so that they are double ringed.

BANDANA

STEP 5
Add dots on the outline of your teardrops and dots over whole nail as a background print.

STEP 4
Add floral motifs around your four-star.

STEP 3
Paint small diamond shapes in neat rows to form a back pattern.

TOP TIP
TAKE INSPIRATION FROM AN ACTUAL BANDANA AND TRY TO MAKE EACH NAIL UNIQUE, BASED ON A DIFFERENT PART OF THE BANDANA

THE FULL SET!

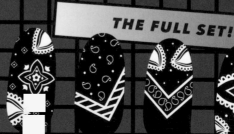

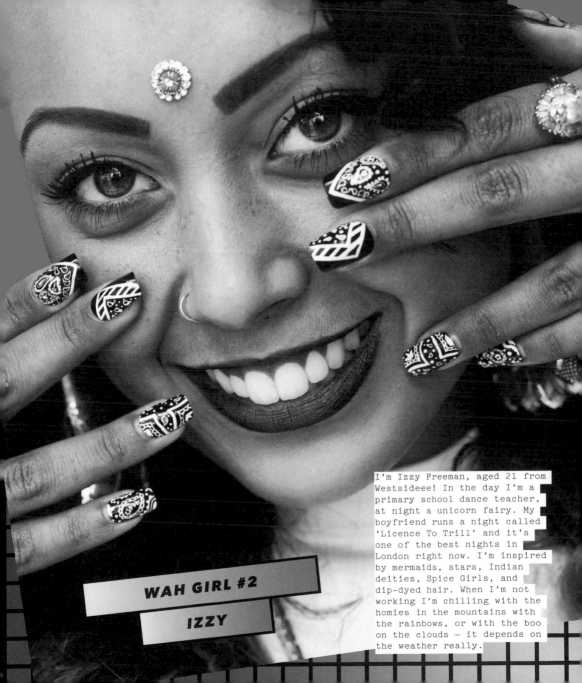

WAH GIRL #2

IZZY

I'm Izzy Freeman, aged 21 from Westsideee! In the day I'm a primary school dance teacher, at night a unicorn fairy. My boyfriend runs a night called 'Licence To Trill' and it's one of the best nights in London right now. I'm inspired by mermaids, stars, Indian deities, Spice Girls, and dip-dyed hair. When I'm not working I'm chilling with the homies in the mountains with the rainbows, or with the boo on the clouds — it depends on the weather really.

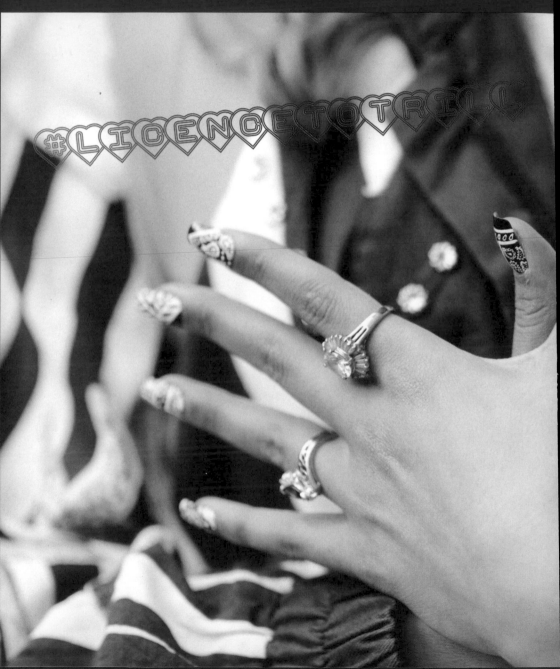

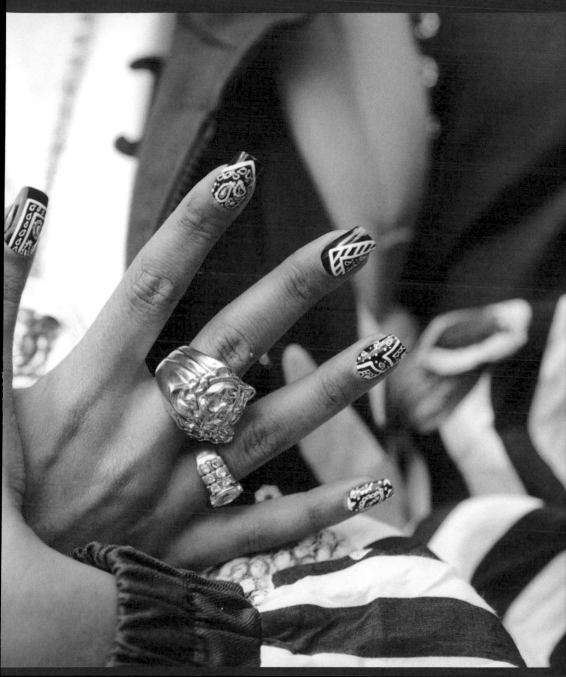

MP NAILS

A FULLY FLEDGED MEMBER OF OUR DOWNTOWN CREW WORLDWIDE, WE MET MADELINE POOLE THROUGH ONE OF OUR BFF'S AARON BONDAROFF, AND HAVE REMAINED FIRM NAIL-GAME-FRIENDS EVER SINCE! GOING BY THE NAME OF MP NAILS, SHE'S GOT A MASSIVE FOLLOWING ONLINE, HAS JUST RELEASED HER OWN BOOK AND IS ONE OF THE COOLEST, NICEST NAIL TECHS YOU'LL EVER GET THE PLEASURE OF MEETING. WE CAUGHT UP WITH HER TO CHAT ABOUT HER UNCONVENTIONAL NAIL TRAINING AND HER FAVOURITE NAIL ARTISTS!

I'm from Baltimore MD, originally, but I currently live in between LA and New York (but mostly LA). It's weird, I never set out to be a nail artist, but all my life I would paint my nails and then immediately scratch it off (I still do that). I remember this one time I wanted to add an accessory to my outfit one night and all I had was some acrylic paint and topcoat. I painted the Hello Kitty French-tip — I'd seen pictures of it before — and my outfit was immediately about ten-times better! It was so fun and rewarding, and I was instantly hooked.

My training was kind of unconventional. I was always training but not intentionally. I worked with my mum who was a muralist, faux finisher and furniture painter and growing up she taught me how to fake marble, wood graina and that classic two-colour floral swirl you see on a lot of country furniture. A lot of those techniques I still use. I also went to an art school for college and majored in painting. During college I worked for a poster restoration shop which was basically five years of miniature painting. Finally, I went to beauty school which was good for sanitation and the more technical side of manicuring.

I've been lucky in that I've always worked freelance and that means I get to travel to different locations everyday, so I have a mobile kit, instead of a steady salon base. I've been working like that for about a year and a half. I always knew I didn't want to work in a salon. Instead I wanted to nails on set as a part of photo shoots. When I began I gave up any source of income I had, quit my various odd jobs, put myself through beauty school and did a ton of free work. It was a big leap financially. Eventually I figured out a way to make a living.

My vibe when I'm doing nails? It depends on the environment, because my location and scenario is always changing. Sometimes it's very relaxed and sometimes it's high stress, high speed. I always try to stay as calm as possible so my hands don't shake. I like to use all natural, organic lotions and essential oils so it smells like we're at a spa. An on-set manicurist is usually in a bit of hurry though, so that's a constant theme that I try to defeat with a peaceful state of mind.

My favourite nail artists right now? I've got a few. Eichi Matsunaga is an on-set manicurist in Tokyo. He also has an unbelievable press-on line called Nail Chip, that are perfect for on-set manicurists who need trendy nails in an extreme rush. I've always loved Disco Nail, Nagisa, also from Tokyo. She's brilliant. Jin Soon Choi is also great — she's an on-set manicurist in NYC who's been working as a freelance nail stylist since the '90s and I think she's really paved the way for people like me who are just getting into the job. She does a lot of fashion magazines and runway shows and has a line of her own beautiful nail colours. And lastly, *The Holy Nail*, although is not a nail artist, she, Sasha, has excellent blog where she collects all the best nail looks of the week from all different sources.

My advice to young people starting out is to first of all learn how to paint a beautiful, one-colour nail. Learn how to do a perfect, classic manicure and you're set to go. What's next for the future? I've made a book, *Nails, Nails, Nails* with Chronicle Books. I've worked on a few products and would like to continue working in product development. Hopefully I'll come out with my own line of press-ons and nail accessories. And eventually branch out, because I'm not only interested in nails, I'm interested in doing much, much more.

This look was inspired by the 90s-style micro-floral dresses we wear all summer, Riot Grrrls, and a general grunge vibe. Black, white and yellow is such a strong colour palette that we knew these nails would work almost immediately. Sometimes the simplest designs are the most

YOU WILL NEED:
· black polish
· white nail art pen
· yellow nail art pen

STEP 1
Paint your base black.

STEP 2
Squeeze your white nail pen gently until a blob of polish has formed on the tip. Make five dots in a circle shape onto the nail. These are your daisy petals.

DAISIES

STEP 3
Repeat all over the nail until you have 4–5 dotted circles.

STEP 5
Using your yellow nail pen, squeeze a large yellow dot in the middle of each dotted circle.

STEP 4
With your black nail pen, add little flicks in each white petal.

TOP TIP
IF YOU ARE ADEPT WITH YOUR NAIL PEN, YOU CAN FLICK EACH PETAL BLOB INWARDS TO FORM A TEARDROP SHAPE. OTHERWISE A CIRCULAR DOT WILL BE FINE!

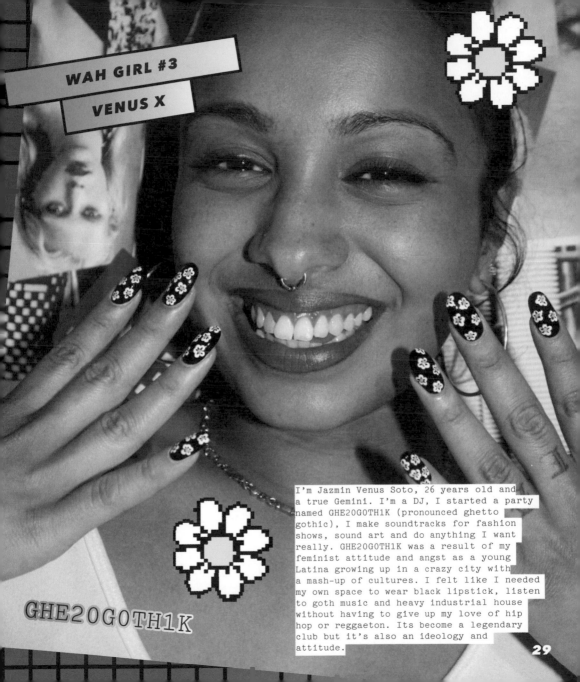

GHE20GOTH1K

I'm Jazmin Venus Soto, 26 years old and a true Gemini. I'm a DJ, I started a party named GHE20GOTH1K (pronounced ghetto gothic), I make soundtracks for fashion shows, sound art and do anything I want really. GHE20GOTH1K was a result of my feminist attitude and angst as a young Latina growing up in a crazy city with a mash-up of cultures. I felt like I needed my own space to wear black lipstick, listen to goth music and heavy industrial house without having to give up my love of hip hop or reggaeton. Its become a legendary club but it's also an ideology and attitude.

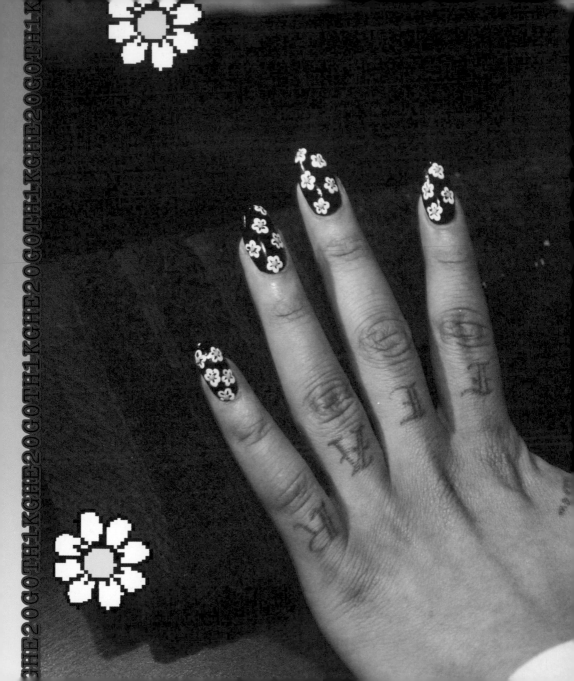

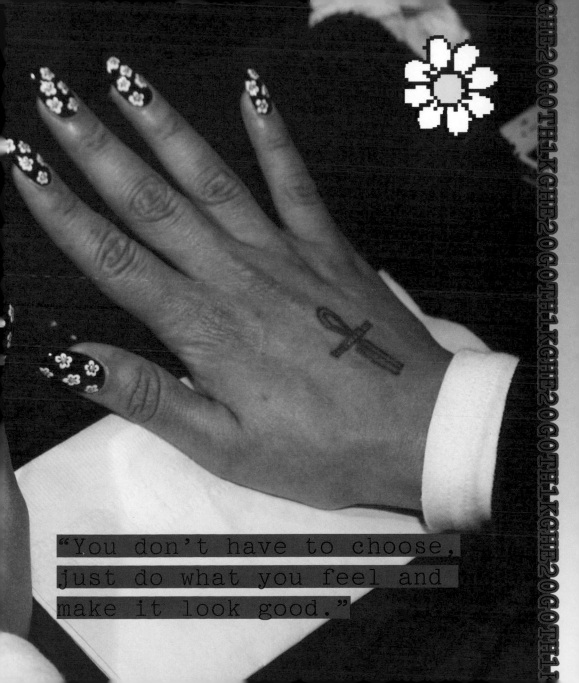

"You don't have to choose,
just do what you feel and
make it look good."

VENUS X

DJ, PROVOCATEUR AND GENERAL MOVEMENT MAKER, JASMINE VENUS SOTO STARTED HER CLUB NIGHT GHE20G0TH1K IN NEW YORK CITY AND IT QUICKLY BECAME A SIREN CALL TO AN ARMY OF OUTSIDERS WHO FOUND SOLACE IN HER ALTERNATIVE MESSAGE. ALTHOUGH THAT MESSAGE MAY NOT BE FOR EVERYBODY, WHAT WE LOVE ABOUT HER IS THAT SHE HAS ONE. HER MUSIC STYLE IS DRAMATIC AND INTERNATIONAL - BANGRA HITS SIT OVER AN AALIYAH REMIX, OR SID VICIOUS SLOWLY SINGS OVER CRAZY TRIBAL BEATS. HERE SHE TELLS US WHAT MADE HER START HER MOVEMENT AND WHAT HER PLANS ARE FOR THE FUTURE.

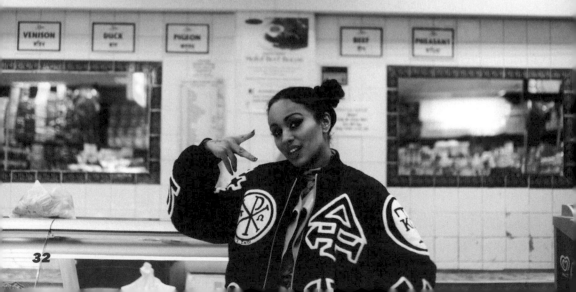

In the summer of 2009 I begged my boyfriend at the time to teach me how to DJ. He gave me a five-minute lesson at Topshop during a live gig and left me to DJ for two hours without any help. I had to learn really fast. That Halloween I threw my first GHE20G0TH1K at a small bar in Brooklyn and each month it got bigger and bigger — it evolved from punk, goth and rap music over time to all different styles of dance music. By the following spring I was throwing it in the basement of a small club in the lower East Side and it was one of the most exciting parties in New York — celebrities, artists, skaters, uptown kids, feminists, college kids, even bridge-and-tunnel people were coming, and all of the DJs were all bringing a different sound or style to the table.

I created GHE20G0TH1K naturally, but over time I realised I really needed it and so did other kids. My friends around me were all part of the same city, had the downtown upbringing and we all were on the same wavelength in music or fashion. Right when I started the party I had a blog where I'd talk about things I thought were GHE20G0TH1K. My first entry posts were about House of La Dosha, Gangsta Boo, Hood By Air and Chicago Juke. The party just tied in everything I was thinking about into one room. I would hire House of La Dosha to perform or host, Shayne from Hood By Air to DJ, and eventually Gangsta Boo even played the party! We had many Chicago DJs come to play as well. It was a moment to create a new culture for the underground, for the youth to have its own identity that wasn't just different, but also acknowledged that we were angry and dark, but still liked what we grew up with, like hood and Spanish music.

The club is a style and sound movement. It's about NOW! It's about the moment where all your inspirations and your ideas come together and you do exactly what you want without worrying about anyone. It's about being a little 'Ruff Ryder' and wearing a choker with a leash, but yet still going home to your Dominican grandma and saying your prayers at night. You don't have to choose, just do what you feel and make it look good. The people and the music made this club so special. There was so much genuine friendship and homies that came together to host, bartend, do the door, take photos, perform and DJ, that it is a true community that has ups and downs and goes through different emotions which we deal with by dancing and having fun together. The club had a lot of amazing people involved and still does and it attracts so many inspiring people from the coolest unemployed punks to the most famous fashion designers and pop stars. There is something for everyone and no one is judged or turned away.

My inspiration comes from who I am and who I became. I am a Dominican girl raised in a small uptown bubble exposed to mostly Spanish music, hip hop and MTV growing up. I became a feminist punk with a love for sounds and art, and that shaped me into a GHE20G0TH1K girl. I look up to Lil' Kim and DMX because their personal style and presence was so powerful and dark, but hood. I am inspired by anime illustrations because the women are voluptuous and fantasy based, but yet childlike. I love motorcycle and sports aesthetics because I always hated fashion and dressing like a girl. I am really inspired by Nine Inch Nails, Janet Jackson, Ivy Queen, Mobb Deep and lots of artists who showed us the dark side of life and music whether through their personal style or their sound.

Whats next for the future? I want to bring GHE20G0TH1K to kids around the world through international parties. I would also love to have a website with a store and TV show so that girls and boys who feel like I did have a place to get a piece of the culture and learn about music and fashion and hopefully become inspired to do exactly what they want.

The word DOWNTOWN means a lot to us. The majority of
WAH Girls are not from the big city, but they have
a 'downtown' state of mind. We're all into the same
things - art, music, fashion - no matter where we are
across the globe, and so we like saying that WAH is for
'Downtown Girls Worldwide'. The downtown nail design
here is influenced by the true downtown of New York City,
the place that two of our fave artists, Keith Haring and
Jean-Michel Basquiat, made their home. Paying homage to
their motifs, we've blended the street vibe together to
create a fun, pop nail design for the DGW crew.

STEP 1
Paint your base
nail half orange
half yellow. don't
worry about doing it
neatly as you won't
notice any mistakes
once you've painted
the print.

YOU WILL NEED
· orange polish
· pink polish
· black nail art pen

TOP TIP
CHOOSE 3 OR
4 LARGE MOTIFS
FROM YOUR
FAVOURITE ARTISTS
AND REPEAT OVER
THE NAIL.

DOWNTOWN

STEP 5
Fill in remaining
gaps with dots,
dashes and commas.

STEP 3
Add dog shapes.

STEP 2
Using your black nail
art pen, start with a
Basquiat-style crown on
each nail. Put them in
a different place every
time and make some come
off the nail.

STEP 4
Fill in large gaps
with swirls.

MOTIF PALETTE

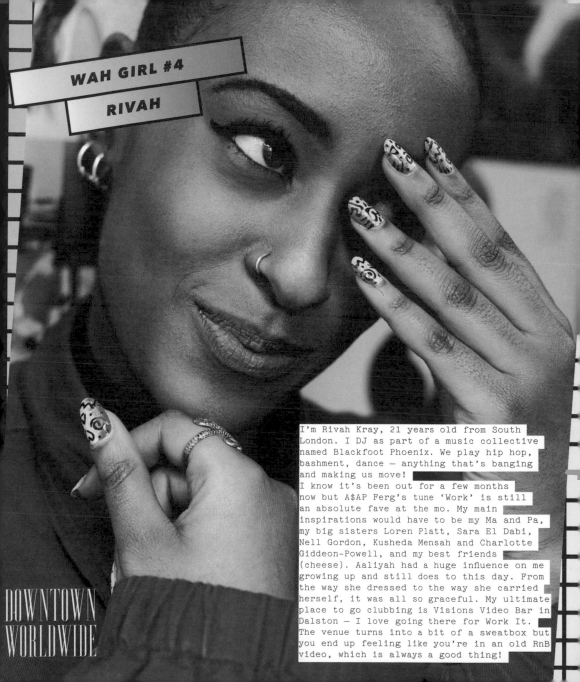

WAH GIRL #4

RIVAH

I'm Rivah Kray, 21 years old from South London. I DJ as part of a music collective named Blackfoot Phoenix. We play hip hop, bashment, dance — anything that's banging and making us move!

I know it's been out for a few months now but A$AP Ferg's tune 'Work' is still an absolute fave at the mo. My main inspirations would have to be my Ma and Pa, my big sisters Loren Platt, Sara El Dabi, Nell Gordon, Kusheda Mensah and Charlotte Giddeon-Powell, and my best friends (cheese). Aaliyah had a huge influence on me growing up and still does to this day. From the way she dressed to the way she carried herself, it was all so graceful. My ultimate place to go clubbing is Visions Video Bar in Dalston — I love going there for Work It. The venue turns into a bit of a sweatbox but you end up feeling like you're in an old RnB video, which is always a good thing!

DOWNTOWN
WORLDWIDE

VASHTIE KOLA

VASHTIE KOLA, AKA DOWNTOWN'S SWEETHEART, IS ONE OUR FAVOURITE NEW YORKERS. SHE'S ALWAYS ONE OF THE FIRST GIRLS WE CHECK-IN WITH WHEN WE ARRIVE IN THE BIG APPLE. ARTIST, DIRECTOR, DESIGNER AND PARTY PROMOTER (HER PARTIES ARE THE DOPEST), SHE EPITOMISES THE NEW YORK 'HAVE-IT-ALL' MENTALITY. NOT CONTENT WITH JUST BEING A PRETTY FACE, SHE TALKS TO US ABOUT AMBITION, HER INSPIRATIONS AND BREAKING THROUGH PREJUDICES IN THE MUSIC WORLD.

I live in the East Village in New York City and it's hard to say exactly what I do cos I do many things! I direct music videos for the likes of Justin Beiber and Solange, I'm Owner and Creative Director of my brand Violette which has collaborated with Brand Jordan And Beats By Dre, I throw my own '90s-themed party called '1992' which has travelled around the world, I am creative consult for other companies and I'm an artist! I guess I could just sum up my job as being a Creative. I make things!

As far as I can remember, I've always loved the movies. I was a young cinephile with a taste for films beyond my age range like: *Rebel Without a Cause*, *Black Orpheus*, *Tron* and more. I didn't grow up watching kid movies because I grew up with an older brother and sister who were seven and eight years older than me. I watched what they watched. When my sister was in high school, she got a job at a movie theatre and my mum would drop me off when she had to work nights. I loved it there. I was this little kid roaming from theatre to theatre, watching anything. When I got to about eleven or twelve I became obsessed with the format of music videos, (that was when MTV was still playing them). In my eyes it was a perfect marriage of music and film, and I loved both. Videos like Method Man & Mary J. Blige's 'All I Need' and Bjork's 'Human Behaviour' really inspired me, and ultimately made me decide on my career as a director.

After I finished high school, I went to The School Of Visual Arts for Directing and Cinematography. I interned a lot and eventually in 2006, set up directing professionally on my own, just after I graduated from Film School. Obviously, it wasn't easy initially setting up on my own. In the beginning, work wasn't steady so I had to work other jobs to support myself. I didn't mind it much because I loved being able to direct. I also directed a lot of videos for free just so I could build my resume and experience. You definitely learn more through experience than you will in a class. I also had to find my directing style. Having a vision is one thing, but perfecting your execution is key. It takes time.

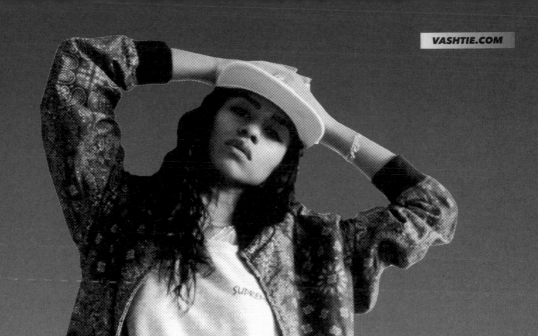

The vibe when I'm working is usually quite serious. I'm rigid with my vision, but from time to time I can make jokes and have fun. It's important to keep the work moving since time is money when it comes to production, but it's also key to keep the spirit of the team high.

Being a woman, I definitely felt like I had to prove myself. When I started and I was unknown, I would walk on my sets and production assistants would assume I was 'talent' (one of the models or actors!). On top of that, many of the production crew I worked with were older than me and I also had to prove that I was not only more than just a girl, I was also more than just a kid. I look up to a lot of people such as Patti Smith, Warhol, Ralph Lauren, Tommy Hilfiger, Oprah, Charles and Ray Eames, Chloe Sevigny, Donna Karan, Madonna and James Jebbia. I'm inspired by other creatives who created their own lane.

I guess a lot of my inspirations are quite British — I think growing up in the eighties and '90s and being exposed to MTV, when MTV was a cultural phenomenon, influenced that. I also know that my brother and sister were super inspirational in their interests. I was so obsessed with them when I was young and everything I like now is mostly what they put me on to; artists like Peter Gabriel, The Petshop Boys, The Cure, Depeche Mode, Tears for Fears and Neneh Cherry.

My advice for people wanting to get into music videos is, if you can afford it, attend film school and learn theory as well as production. If you can't, then pick up a camera and get an apprenticeship with a filmmaker. What I love about this moment in time is that filmmaking has become more accessible and affordable so if you have an interest in it, it's not hard to create a name for yourself. On the flip side, what I hate about this moment in time is that everyone thinks they can be a director because they have a camera at their disposal! You have to set yourself apart starting with your vision and style. Perfect your craft, study and shoot as much as you can.

My mantra for life? One step at a time!

37

There are so many different types of flower prints out there that you will find endless inspiration if floral nails are your thing. The key with flower prints is highlights. When you've decided on the shade of your flowers, choose a colour from the same family that's lighter and one that's darker. Use all three colours on your flower to add highlights and lowlights for a real print effect. We've gone for a pink rose print with green vines that will give you the basic skills for your own spectacular flower nails.

YOU WILL NEED
· white polish
· dark pink polish
· light pink polish
· green nail art pen
· empty striper for detail work

STEP 1
Paint your base colour white.

STEP 2
Using your pink striper brush, draw a large flower on your nails and two smaller ones coming off the nail.

FLORAL

STEP 3
In a different shade, paint a smaller and different flower shape in the gaps.

STEP 5
Using two shades of green draw vines and leaves to join your flowers together.

STEP 4
Using your lighter and darker shade, outline your flowers and the individual petals.

TAKE IT TO THE NEXT LEVEL USE A PAINT PALETTE TO MIX YOUR FLORAL COLOURS TO GIVE YOUR DESIGNS HIGHLIGHT

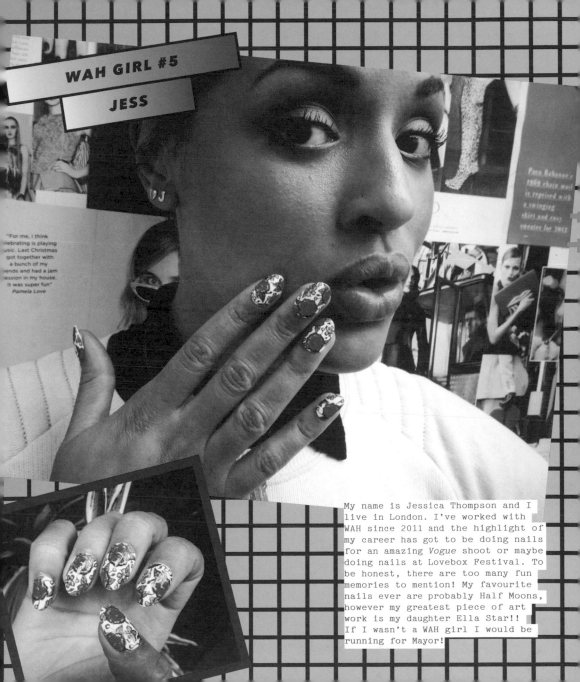

WAH GIRL #5

JESS

"For me, I think celebrating is playing music. Last Christmas I got together with a bunch of my friends and had a jam session in my house. It was super fun"
Pamela Love

My name is Jessica Thompson and I live in London. I've worked with WAH since 2011 and the highlight of my career has got to be doing nails for an amazing *Vogue* shoot or maybe doing nails at Lovebox Festival. To be honest, there are too many fun memories to mention! My favourite nails ever are probably Half Moons, however my greatest piece of art work is my daughter Ella Star!! If I wasn't a WAH girl I would be running for Mayor!

INTO THE GLOSS

WHEN FORMER VOGUE STYLIST EMILY WEISS LAUNCHED INTOTHEGLOSS.COM IN SEPTEMBER 2010, IT QUICKLY BECAME CLEAR THAT HERS WAS A BLOG LIKE NO OTHER. WITH EXCLUSIVE INSIGHTS INTO THE GROOMING REGIMES OF ELITE INDUSTRY INSIDERS AND A SOPHISTICATED FASHION MAG AESTHETIC, INTO THE GLOSS SET ITSELF APART BY OFFERING A UNIQUE, CHIC, AND WELL, GLOSSY, TAKE ON MODERN BEAUTY. ALMOST THREE YEARS LATER, INTO THE GLOSS - OR ITG, AS IT'S KNOWN TO ITS LOYAL FOLLOWERS - HAS EVOLVED INTO AN AUTHORITATIVE BUT INCLUSIVE ONLINE VOICE THAT REGULARLY FEATURES THE MOST HIGH-PROFILE BEAUTY AFICIONADOS IN THE WORLD (THINK DITA, CARA, IMAN…). ITG ALSO COLLABORATES WITH TOP BRANDS LIKE BUMBLE & BUMBLE, GUCCI AND DIOR TO RUN EXCLUSIVE SPONSORED CONTENT THAT'S CREATED BY - AND SOMETIMES STARRING - ITS FULL TIME STAFF OF FIVE SUPER-COOL NEW YORKERS. NOT BAD CONSIDERING THAT, UNTIL LAST SUMMER, EMILY WAS PRODUCING EVERY INTERVIEW, FEATURE AND PHOTOGRAPH ENTIRELY ON HER OWN. INSPIRED? WAH SPOKE TO EMILY TO FIND OUT EXACTLY HOW SHE TURNED A PASSION FOR BEAUTY INTO A FULLY-FLEDGED BUSINESS (AND HOW YOU CAN DO IT, TOO).

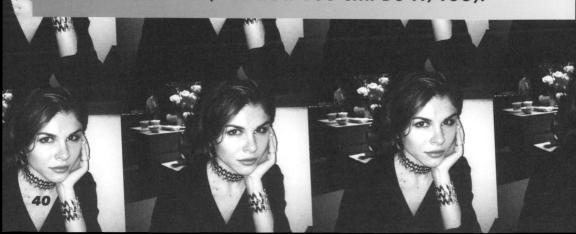

WAH: HOW DID THE IDEA FOR INTO THE GLOSS COME ABOUT?

The idea came about in the summer of 2010, around August time. I was a fashion assistant for a stylist at American *Vogue*, and I was constantly being inspired by the hair and make-up artists who were around me. I didn't see a lot of that being featured anywhere, especially online. So I wanted to take that magazine approach to content to create a really chic and elevated beauty website.

WERE YOU LOOKING FOR AN ESCAPE ROUTE FROM THE JOB YOU HAD AT THE TIME?

No, It was a just part of a natural progression. I'd been at *Vogue* for two years and was wondering what my next step was going to be. I was considering a lot of different paths, as all recently graduated twenty-somethings do, and it was at a point in time when digital was taking off with a newfound focus. If you're someone who has ideas, it's a lot easier to create a website than it is to create a printed magazine.

HOW QUICKLY DID YOU GET READY FOR LAUNCH?

It happened very fast. When I get excited about something, I tend to work pretty quickly. And with a website, it's quite straightforward — you just have to buy a URL. The hardest part is assembling a team of talented people around you who share your vision. Our digital director Michael Harper designed the site with me and it really was just a 'right place, right time' situation with him. We came together and got the site up and running in about two weeks.

FROM THE START, YOU'VE MAINTAINED VERY HIGH EDITORIAL STANDARDS….

I think that comes from having such great training. I'd worked in so many parts of a magazine, right from when I was an intern at *Teen Vogue*. I worked in the fashion closet, I was scouting stories, I was writing stories. I think the great thing about all these magazines is all the perfectionism and professionalism that you really carry with you.

AND YOU WERE INITIALLY DOING ALL THE INTERVIEWS AND TAKING ALL THE PHOTOS BY YOURSELF?

Until July 2012, I was producing the content entirely on my own. That's when we went from [a team of] one to five.

HOW DID YOU FIND THE TIME?

It was crazy, I was waking up at 4am everyday to edit pictures, or text, or to write. I did most of my shoots on the weekends. It depends on the kind of website you have, but if you're producing original content it's not a quick, easy thing. It takes work.

DO YOU THINK IT'S IMPORTANT TO KEEP YOUR DAY JOB WHEN YOU'RE LAUNCHING A NEW BUSINESS?

You can't be naïve, but you also shouldn't play it too safe. No guts, no glory is my attitude to most things! With *Into The Gloss*, I always hoped it would become a full-time business but that takes time. Especially if you're doing something in a new medium that's a little bit of out of the box — it's something you have to gauge as you go.

DID YOU HAVE A FIVE-YEAR PLAN?

I think with web, it's hard to have a strict plan. You start out with one, but you have to be super-flexible with it because there are different social platforms launching every other week, it seems. It's hard to say where you'll be in two, three years — you kind of have to roll with the punches.

A LOT OF CREATIVE PEOPLE STRUGGLE WITH MONETIZING THEIR IDEAS AND TALENTS. HAVE YOU HAD TO SEEK ADVICE ON THE FINANCIAL SIDE OF INTO THE GLOSS?

I've had to seek advice from a lot of people on a lot of different subjects. If you're a small business owner, no matter what type of business it is, you're faced with dealing with things you never thought you'd have to deal with. Advice is super-important to me and I love to people I've worked with at magazines as well as people in the tech space. And Mum and Dad.

A LOT OF WHAT MAKES INTO THE GLOSS GREAT IS THE INSIDER ACCESS TO ALL THESE AMAZING FASHION AND BEAUTY FIGUREHEADS. HOW DID YOU DEVELOP AND GROW YOUR SOCIAL NETWORK?

I'm lucky — I started working in magazines when I was 19. By the time I started the site I was 25, so I have six years of different contacts both amongst my peers and then of course all the people I'd worked with on shoots — models like Karlie Kloss and Inez Van Lamsweerde.

YOU HAVE TO TAKE RISKS

I knew my fair share of people, but I certainly didn't have them on speed dial! But that did not stop me from telling them what I was working on and being really, genuinely excited about it. If you're starting something new and you're working hard, you have to reach out to people and show them that you're passionate about it. What's the worst that can happen? They say no or they don't write you back. That's never stopped me — I think you have to go for it.

HAVE YOU EVER STRUGGLED WITH CONFIDENCE?

No! I've had my 'crying under the desk' moments, like everyone. But like I said, what's the worst that can happen? You have to take risks. If you believe in something, then you have to go for it or else how happy are you going to be anyway, doing something else and knowing that you never tried? Especially if you're young. This is the time to do that type of thing, I think. Or at least, that's what people have told me!

YOUR PERSONAL BEAUTY REGIMES FORM A FUNDAMENTAL PART OF INTO THE GLOSS. HOW IMPORTANT IS IT TO BE THE FACE AND VOICE OF YOUR BUSINESS?

I think it's important in the way that editors-in-chief of magazines are involved: that's how I'm used to seeing figureheads operate. It's

not overwhelming, it's not all about them, but it's about whatever they're curating. That's how magazines come to be because ultimately it's the editor's vision. I've never really sought to make the site about me at all. That gets old really fast — what happens when I'm 55 years old and not 23 and running around town in mini-skirts or whatever I was doing when I was 23? It's not sustainable to try to make something all about you.

My interest has always been primarily in women. I think women are amazing and there are so many types of beauty and style. I'm much more interested in hearing people's advice and tips and tricks — that's what informs me. I wouldn't say I make many of my beauty decisions based on things that I stumble upon. Most of it is because other of people.

DO YOU FEEL THAT YOU'RE HELPING TO REDEFINE MODERN NOTIONS OF BEAUTY?

I think part of what we do, and part of what I always get excited about, is when you're forced to think about something in a different way. There's obviously a very prevalent message of what the norms are for beauty, especially the celebrity norms, and how girls should look pretty... I think it's interesting to think about other ideas. It's something that girls think about a lot, whether they realise it or not. So it's nice to have a dialogue about it.

WHAT'S THE WORST THAT CAN HAPPEN?

YOU RECENTLY TOOK ON FOUR STAFF MEMBERS. WHAT'S IT LIKE BEING THE BOSS?

t's so hard! No one tells you how to do that – you just have to figure it out as you go. I've earnt that it's really important to empower eople. Something we say at ITG all the time s that we're only ever as good as our ideas. he smaller the team, the more important every ingle person is in on it.

t doesn't matter what your job is – if you ave great ideas and lots of ambition – that ou're encouraged to self-start. That's omething I learnt at *Teen Vogue*. I was an ntern and because I was so interested in torytelling and finding girls for the magazine, he editor in-chief ended up saying: 'Well, reat! You just found us our backpage'. Great deas can come from anyone and anywhere. ou just have to go for it and not just do hat's expected.

WHAT IS THE BEST THING THAT HAS COME OUT OF LAUNCHING ITG FOR YOU ON A PERSONAL LEVEL?

I get most excited when I shoot someone really fun. I come back to the office sometimes after a great shoot or meeting and I'm high from it. If I weren't meeting new people all the time, I would get really sad.

WHAT ADVICE WOULD YOU GIVE TO SOMEONE HOPING TO LAUNCH THEIR OWN BUSINES, ONLINE OR OTHERWISE?

I would say that things take time. And that's something that my generation and younger people are not used to putting in. You expect things to be immediately successful but you have to understand that it's going to take a minute for things to take off or gel. It's important to really commit.

If you want to start something new, passion is great and excitement is great, but you have to also make sure you have the right training. A lot of people think, 'Oh, I'm just going to become a designer or launch a website'. But you have to think: A) What's your point of difference? And B) Do you have the tools you need to make this work?

Time and training are super-important, as well as original ideas. There's a lot noise – fashion is a very crowded industry, beauty also — you have to have something original to say.

Galaxy nails are such a fun project! Using a mix of colours and a sponge, treat your nails like a palette mixer. Don't worry about using fresh sponges for each nail — you'll soon get an amazing mix of colours that will add to your design. The white base make the colours pop but if you want a more subtle Galaxy design you can omit this step. Try them! These nails are outta this world! (Sorry, we had to say it…)

YOU WILL NEED

· black nail polish
· white nail polish
· paper towel
· a sponge
· magenta pink nail polish
· light blue nail polish
· jade green nail polish
· lilac nail polish
· purple nail polish
· orange nail polish
· yellow nail polish
· a white nail striper
· a white nail art pen

GALAXY

STEP 1
Paint your nails with the black base colour and allow it to dry.

STEP 2
Paint white polish on your sponge. Dab the excess off on a paper towel and then lightly dab the sponge on the area you want to create the galaxy appearance on your nail. Go across each nail in different directions.

STEP 5
Use your white nail art pen to create dots in the black areas to look like stars.

STEP 3
Sponge on two colours per nail onto the white areas you have made. Make sure you overlap them with each other a little.

STEP 4
With a striper create the cross shape over the sponged colours.

TOP TIP
TINY SWAROVSKI CRYSTALS COULD REPLACE THE TINY STARS FOR INTERGALACTIC SPARKLE!

44

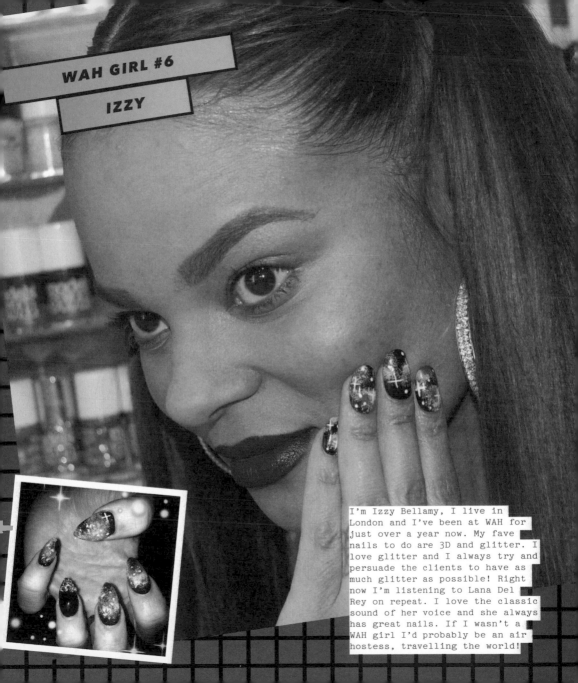

WAH GIRL #6

IZZY

I'm Izzy Bellamy, I live in London and I've been at WAH for just over a year now. My fave nails to do are 3D and glitter. I love glitter and I always try and persuade the clients to have as much glitter as possible! Right now I'm listening to Lana Del Rey on repeat. I love the classic sound of her voice and she always has great nails. If I wasn't a WAH girl I'd probably be an air hostess, travelling the world!

WORK IT

MUCH LIKE WAH, WORK IT STARTED AS PART OF A SMALL EAST LONDON CREW AND HAS SINCE ACHIEVED WORLDWIDE DOMINATION ON THE CLUB SCENE. FAR FROM BEING JUST A RAVE NIGHT, LOREN PLATT AND SARA EL DABI HAVE CREATED A BRAND THAT HAS SEEN THEM WORK WITH SELFRIDGES AND THE ICA, CREATE THEIR OWN T-SHIRT LINE AND MUCH, MUCH MORE. AFTER CELEBRATING THEIR FIFTH BIRTHDAY WITH AN EPIC PARTY, WE SAT DOWN AND CHATTED TO THEM ABOUT THEIR HUMBLE BEGINNINGS, CLUBS AND THE KEY TOOLS TO MAKE YOUR NIGHT A SUCCESS.

Work It came to life five years go because of our frustrations with London's club scene. We just wanted a place to dance to nineties hip hop and RnB without having to pay crazy prices for one drink — as the only clubs that were playing that kind of music were cheesy and expensive clubs in the West End. We loved hanging out in East London but the sound wasn't right. So we decide to do our own night and see what happens. We stumbled upon the perfect venue. Visions Video Bar was a basement club in Dalston that was run by Jamaicans and had a chilled, homely feel. It was very much a family vibe and thats what we wanted. The first Work It was a proper family affair. We made no money, didn't really have a DJ and were totally clueless, but it was also the funnest night of our lives. But then 'word got out' and the night became popular and we realised there

were other people who wanted to dance to 90s RnB too! Now it wasn't just our mates turning up and we knew it was serious when we started to get long queues every night! the *Guardian* newspaper wrote a piece on us and then all of a sudden it got crazy!

Years later, it's so exciting because we've got a whole new generation of budding DJs who have helped the brand evolve and have brought a new energy to it. That's a big part of the club's success. We don't wanna go out as much now we're a bit older, but we have a family who represent the brand - sharing it with other people is important.

We've just celebrated our fifth birthday party with a huge event; created a T-shirt line thats stocked in Urban Outfitters and have DJs in some incredible places all over the world! Its been a truly amazing experience.

WORK IT

is coming to MANCHESTER! Sat 25th July The Deaf Institute 90's HIP HOP & RNB

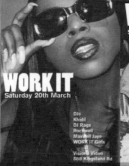

WORK IT
Saturday 20th March

DJs
Khalil
DJ Rags
Rockwell
Maxwell Jaye
WORK IT Girls

Visions Video
588 Kingsland Rd

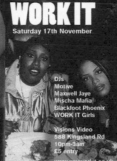

WORK IT
Saturday 17th November

DJs
Motive
Maxwell Jaye
Mischa Mafia
Blackfoot Phoenix
WORK IT Girls

Visions Video
588 Kingsland Rd
10pm-3am
£5 entry

SATURDAY 2ND JUNE
CONCRETE
9pm - 2am
£5 before
10pm
£6 after

WORK IT

DJs
WORK IT Girls
MAXWELL JAYE
BLACKFOOT
PHOENIX

1Xtra

HOT GAL OF THE MONTH

GOING LIVE ON 1XTRA WITH SURPRISE SPECIAL GUEST !

NENEH CHERRY

WORK IT
Saturday 19th November

DJs
R.O.Z.
Larry B
DJ Rags
Maxwell Jaye
WORK IT Girls

Visions Video
588 Kingsland Rd
10pm-3am
£5 am

WORK IT
1st November

DJs
DJ Snips
Johnny Dett
Think Twice
Maxwell Jaye
Tina Turnover

Visions Video
10pm-3am
£5 entry

WORK IT
Saturday 16th June

DJs
Snips
Larry B
Siobhan Bell
Maxwell Jaye
WORK IT Girls

WORK IT 2nd
BIRTHDAY!
Saturday 17th April
Visions Video
588 Kingsland Rd
10pm-3am
£5 all night

2
ENOUGH
DJs

Work It Girls
Maxwell Jaye
Smuttee
Rockwell (No Requests)
DJ Rivah
Gassy Gas
RadiDadi
Major Dude
DJ Khalil
Oi You!
DJ Rags
V. Special Guest

WORK IT
Saturday 26th June
NOTHING BUT 90s
HIP HOP & RnB

DJs
Darka
Mr Ruscoe
Murkage Dave
Maxwell Jaye
Tina Turnover

THE DEAF INSTITUTE
135 Grosvenor St
10pm-3am £5 entry

WORK IT
Saturday 15th September

DJs
RadiDadi
Island Spicey
Blackfoot Phoenix
WORK IT Girls

Visions Video

WORK IT
CARNIVAL SPECIAL

...SO SPECIAL SO SPECIAL SO SPECIAL

Sunday 30th August
Visions Video
Oi You
White Kids
Johnny Dett
Maxwell Jaye
Blake Melody
WORK IT Girls

WORK IT
16th October

(loud)
Jaye
Girls
Sisters
XL Recordings)

deo
land Rd
m £5 entry

work.co.uk

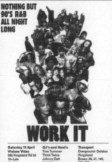

NOTHING BUT
90'S R&B
ALL NIGHT
LONG

WORK IT

Saturday 18 April
Visions Video
588 Kingsland Rd 09
10-Late

DJ's and Host's
Tina Turnover
Think Twice
Johnny Dett

Transport
Overground: Dalston
Kingsland
Buses: 30, 47, 149,

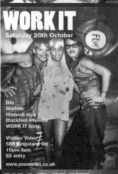

WORK IT
Saturday 20th October

DJs
Martelo
Maxwell Jaye
Blackfoot Phoenix
WORK IT Girls

Visions Video
588 Kingsland Rd
10pm-3am
£5 entry
www.youworkit.co.uk

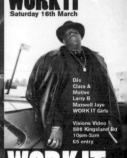

WORK IT
Saturday 16th March

DJs
Clara A
Motive
Larry B
Maxwell Jaye
WORK IT Girls

Visions Video
588 Kingsland Rd
10pm-3am
£5 entry

WORK IT
urday 18th Jun

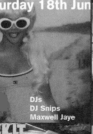

DJs
DJ Snips
Maxwell Jaye

WORK IT
Saturday 15th October

DJs
RadiDadi
Larry B
Maxwell Jaye
Blackfoot Phoenix
WORK IT Girls

Visions Video
588 Kingsland Rd
10pm-3am

Valentines Special
Saturday 14th Feb

WORK IT
Saturday 18th August

DJs
Larry B
RadiDadi
Maxwell Jaye
WORK IT Girls

Visions Video
588 Kingsland Rd
10pm-3am
£5 entry
www.youworkit.co.uk

WORK IT
Saturday 18th February

DJs
Larry B
Radi Dadi
DJ Rags
Maxwell Jaye
WORK IT Girls

Visions Video
588 Kingsland Rd
10pm-3am
£5 entry

Saturday
20 June

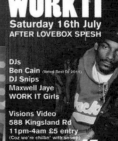

WORK IT
Saturday 16th July
AFTER LOVEBOX SPESH

DJs
Ben Cain (Voted Best DJ 2011)
DJ Snips
Maxwell Jaye
WORK IT Girls

Visions Video
588 Kingsland Rd
11pm-4am £5 entry
(Coz we're chillin' with snoop)

www.youworkit.co.uk

47

WORK IT

TOP 10 TIPS TO STARTING YOUR OWN CLUB NIGHT

Find a venue that suits your vibe - Once you've booked a venue and confirmed a date, it's happening so it means you've gotta get it together.

1

2 **It's always good to have a theme for your club and represent it with all your marketing - Your flyer, website, logo and even the way you dress on the opening night is so important.**

Get yourself some good DJs you can rely on - Think about your music. Is it something you wanna hear and other people wanna hear?

3

Get your mates involved - It's all about promotion, get your flyer up on as many blogs and websites as possible. Make sure you update all your social media sites, get people Tweeting about it, Facebooking the event and instagramming the flyer. Keep a mailing list and make yourself heard!

4

5 **Get yourself a good door girl you can trust! This is the first contact people will have with your club. Make sure he or she is a good representative, with no attitude!**

Be a good hostess and hype the crowd up – Say 'hi' to everyone, check they're having a good time and make sure you get on the dancefloor.

6

7

Make it memorable – What will people talk about the next day? The free lollipops? The epic last song that everyone sang along to? Don't make it gimmicky, but make it fun!

...ke a mixtape of all your key tunes and share ...ith your mailing list – No matter what they ... doing they'll be listening to the songs and ...embering the good times at the club.

8

9

Keep reinventing yourself – Themed nights, guest DJs and special collaborations will keep the crowds coming back. It should keep getting better.

10

Make merchandise – T-Shirts, stickers, keyrings, anything with your logo on it! The club may only be once a month, but now you can be with your fans all the time.

HAUS OF LACQUER

ONE OF THE OG NAILS CREW, STEPHANIE BERRY HAS BEEN AROUND FROM DAY ONE. THERE WEREN'T MANY NAIL BLOGS BACK WHEN WE STARTED IN 2009, BUT STEPHANIE'S WAS ONE OF THE ONES WE REMEMBER. WE CAUGHT UP WITH HER ON HER FAVE TUNES TO PAINT NAILS TO AND WHAT MADE HER WANNA BE A NAIL ARTIST IN THE FIRST PLACE.

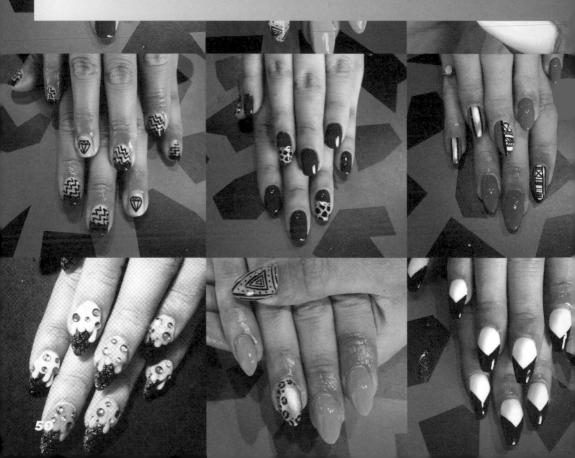

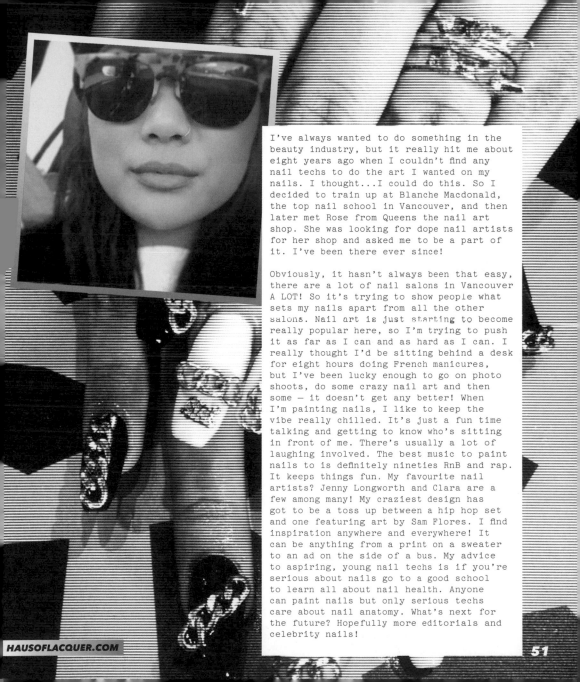

I've always wanted to do something in the beauty industry, but it really hit me about eight years ago when I couldn't find any nail techs to do the art I wanted on my nails. I thought...I could do this. So I decided to train up at Blanche Macdonald, the top nail school in Vancouver, and then later met Rose from Queens the nail art shop. She was looking for dope nail artists for her shop and asked me to be a part of it. I've been there ever since!

Obviously, it hasn't always been that easy, there are a lot of nail salons in Vancouver A LOT! So it's trying to show people what sets my nails apart from all the other salons. Nail art is just starting to become really popular here, so I'm trying to push it as far as I can and as hard as I can. I really thought I'd be sitting behind a desk for eight hours doing French manicures, but I've been lucky enough to go on photo shoots, do some crazy nail art and then some — it doesn't get any better! When I'm painting nails, I like to keep the vibe really chilled. It's just a fun time talking and getting to know who's sitting in front of me. There's usually a lot of laughing involved. The best music to paint nails to is definitely nineties RnB and rap. It keeps things fun. My favourite nail artists? Jenny Longworth and Clara are a few among many! My craziest design has got to be a toss up between a hip hop set and one featuring art by Sam Flores. I find inspiration anywhere and everywhere! It can be anything from a print on a sweater to an ad on the side of a bus. My advice to aspiring, young nail techs is if you're serious about nails go to a good school to learn all about nail health. Anyone can paint nails but only serious techs care about nail anatomy. What's next for the future? Hopefully more editorials and celebrity nails!

Okay, I know what you're thinking; this ones gonna take aaaaaages! But no, seriously, we wouldn't do that to you. That's why we are here — to unleash the nail secrets! Houndstooth is such an arresting design. The graphic of the monochrome looks amazing on almost any skin tone, or if you're feeling adventurous, try a coloured base.

STEP 2
Paint a thick line (double the width of your striper brush), down the centre of the nails with your striper. Repeat on either side so you have three thick vertical lines.

STEP 3
Repeat but horizontally. One line going across the centre and the then another above and below it.

YOU WILL NEED
· black polish
· white striper
· black striper

STEP 1
Paint all your nails with the black polish.

HOUNDSTOOTH

STEP 5
On the left and top side of each black square, extend the square up with a small line, and across with a small line. See! That was easy!

STEP 4
You'll now have your checkerboard nails. Using your black striper, draw two little lines extending diagonally from the bottom and right side black squares. Be careful not the touch the square below it.

TOP TIP
JUST USE THE VERY TIP OF YOU
BRUSH TO DO TH
DIAGONAL LINE
OR A FLICK OF T
NAIL ART PEM

52

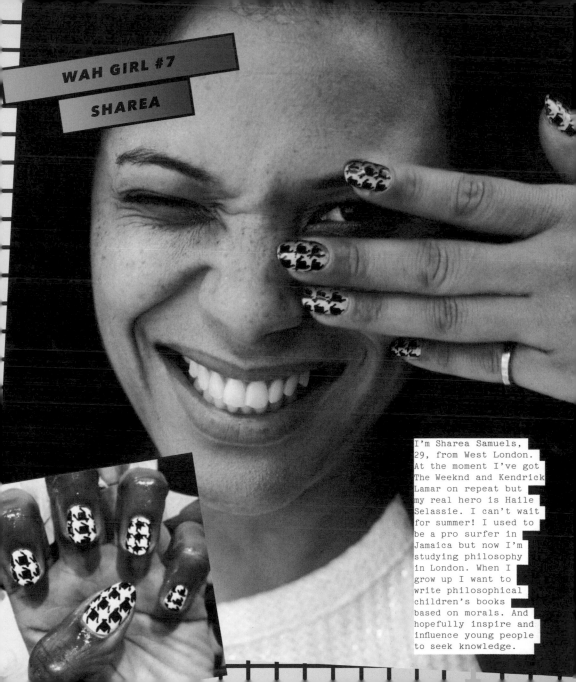

WAH GIRL #7

SHAREA

I'm Sharea Samuels,
29, from West London.
At the moment I've got
The Weeknd and Kendrick
Lamar on repeat but
my real hero is Haile
Selassie. I can't wait
for summer! I used to
be a pro surfer in
Jamaica but now I'm
studying philosophy
in London. When I
grow up I want to
write philosophical
children's books
based on morals. And
hopefully inspire and
influence young people
to seek knowledge.

NAOMI NAILS NYC

JAPANESE NAIL ARTISTS ARE JUST INCREDIBLE. WHEN WE STARTED THE NAIL SALON, JAPAN WAS REALLY THE ONLY PLACE WE LOOKED TO FOR NAILS INSPO. REPPING JP IN THE INTERNATIONAL NAIL CREW IS NAOMI YASUSA. NOT ONLY IS SHE INCREDIBLY TALENTED, BEING ABLE TO DO EVERYTHING ON NAILS FROM 3D SHAPES TO INTRICATE PAINTINGS, BUT SHE IS ALSO GORGEOUS, FUNNY AND COOL.

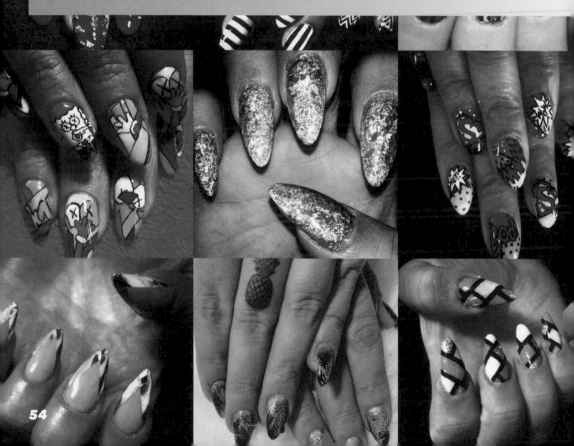

I always knew what I wanted to be. I knew at 13 years old I was going to be a nail artist so I went to nail and beauty school straight after I graduated from high school. I started working at a nail salon in Japan when I was eighteen. I moved to New York five years later and started working exclusively out of a hair salon as their first and only nail artist. It was scary as I didn't know ANYONE in New York or even speak any English, but I was determined and I made it through. Now things have really taken off and I paint nails all day every day. I often do some crazy designs as all my clients keep pushing me to come up with creative, fun stuff which I love because it keeps me on my toes and I never stop creating. I love listening to rap whilst I paint nails — it keeps the vibes good and the clients usually love it. My inspirations can come from anywhere. They don't usually come from other nail artists — I prefer to keep within my own nail bubble! I take most of my inspiration from the visuals I see on a day to day basis, from my friends, art, music or sometimes a fashion spread in one of my favourite magazines.

My craziest design? It has gotta be when I did a collaboration with Barneys and Lady Gaga, that was pretty crazy. And so exciting! My advice to people wanting get into nails is be a good manicurist first. It is SO important. It's the foundation to being a good nail artist. The painting and design you can learn later, but you really need the basics down first. My plans for the future are to bring nail art to a wider audience through product design. I'd love, love, love my own polishes and as I live in NYC and things happen really fast here so you never know what is going to come up!

Japan is our spiritual nail home. If it sparkles, blings, and comes in any shade of pink, it's in! We love doing Japanese-themed nails so much. We wish they'd ship all the fun bits and bobs that you stick on your nails outside of Japan, but unfortunately they don't. So the trick is to hunt online, scour craft stores and bead shops for anything fun that you can stick on your nails. For your own personalised stamp on your nails, you can learn to do 3D acrylic sculptures or create your own 3D shapes using oven-bake clay.

YOU WILL NEED
· 2 different pink glitter polishes
· 1 silver, gold or holographic glitter polish
· Swarovski crystals in a mixture of sizes
· 3D bows and roses
· White Nail Art Pen

STEP 1
Leave the base of your nail nude. After you've prepped and painted a clear base coat, paint a thin layer of glitter over the top half of your nail, using the first pink glitter.

JAPANESE BLING

STEP 5
Apply topcoat over the whole nail, including all your 3D bits and allow to dry.

STEP 3
Using your white nail art pen draw heart outlines on a few nails.

STEP 2
Repeat using the second pink glitter and again with your contrast gold or silver glitter.

STEP 4
Using nail glue, stick on crystals, bows and roses. Place most of them on the middle nail doing less on as you go outwards, so the thumb and little finger just have a few crystals on them.

TOP TIP
SEE PAGES 58-59 ON HOW TO MAKE YOUR OWN 3D SHAPES.

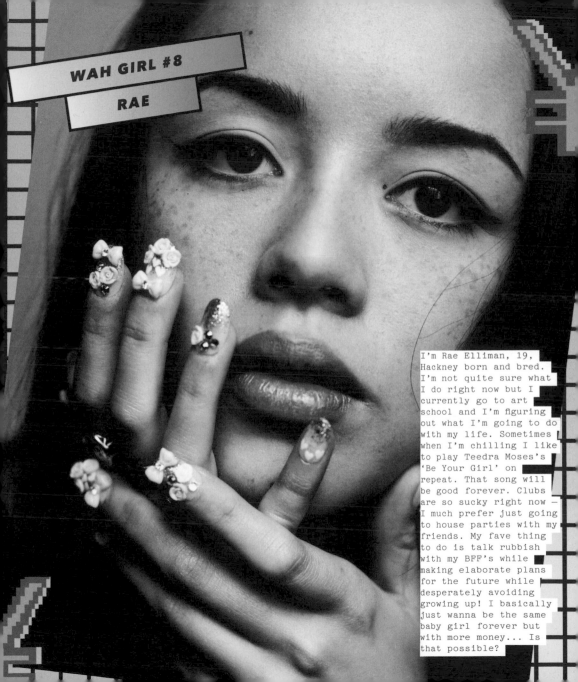

I'm Rae Elliman, 19, Hackney born and bred. I'm not quite sure what I do right now but I currently go to art school and I'm figuring out what I'm going to do with my life. Sometimes when I'm chilling I like to play Teedra Moses's 'Be Your Girl' on repeat. That song will be good forever. Clubs are so sucky right now — I much prefer just going to house parties with my friends. My fave thing to do is talk rubbish with my BFF's while making elaborate plans for the future while desperately avoiding growing up! I basically just wanna be the same baby girl forever but with more money... Is that possible?

3D SHAPES

MAKING YOUR OWN 3D SHAPES ISN'T AS TOUGH AS YOU THINK. WITH A SMALL BRUSH AND SOME PRACTISE, YOU CAN CREATE FUN, JAPANESE-STYLE SHAPES

Ok so let us give you a heads up. Acrylic powder and liquid is a professional product. If you're currently training to be a nail tech and want to take your work to the next level then this is a great way to start, otherwise treat this technique with caution. Monomer should be used in a well ventilated area and should not be inhaled. Once you grasp the basics of managing and sculpting acrylic, the world is your oyster! Soon you'll be saying, why paint hearts when you can sculpt them?! There are whole books, training courses and video tutorials on sculpting acrylic, but we'll just tell you the basics to get your started with this 3D heart.

YOU WILL NEED
- orange stick
- coloured acrylic
- liquid monomer
- acrylic brush
- paper towel
- orange stick

STEP 1
Paint your nail in your base colour and allow it to fully fully.

STEP 2
Pour a small amount of monomer liquid into a metallic container. Dip your brush into the monomer liquid and wipe the excess on the side of the container. Gently blot it onto the paper towel to wipe off even more liquid.

STEP 3
Dip your moist brush into the coloured acrylic making gentle circular motions until you form a ball on the end of your brush.

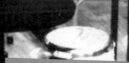

THIS IS THE REAL BASICS. EVEN JUST PICKING UP A PERFECT BALL OF ACRYLIC TAKES HOURS OF PRATISE!

STEP 4
Place the ball on your nail and begin to form your shape. Add more acrylic balls to build up your shape.

STEP 5
Work quickly as the acrylic will be starting to harden and set. Use the sides of your brush and your orange stick to sculpt your shape.

STEP 6
Pat your shape down flat and once its complete dip your brush in monomer liquid and give it a sweep over to smooth any lumps.

STEP 7
Once its fully dry, topcoat your whole nail.

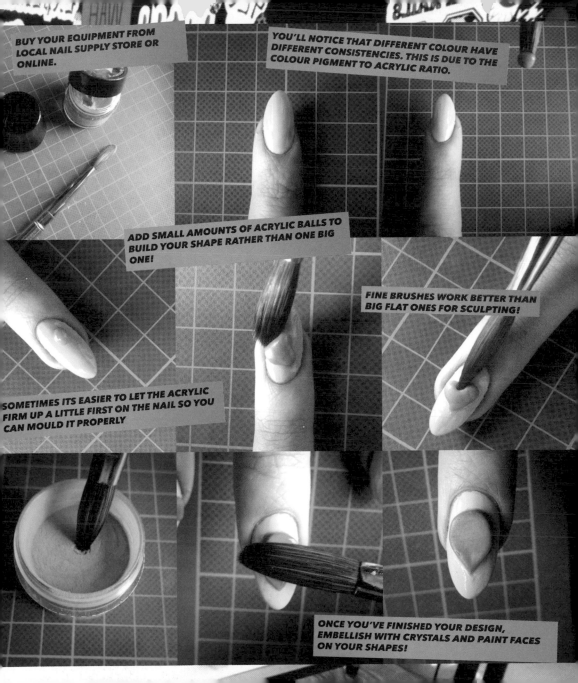

BUY YOUR EQUIPMENT FROM LOCAL NAIL SUPPLY STORE OR ONLINE.

YOU'LL NOTICE THAT DIFFERENT COLOUR HAVE DIFFERENT CONSISTENCIES. THIS IS DUE TO THE COLOUR PIGMENT TO ACRYLIC RATIO.

ADD SMALL AMOUNTS OF ACRYLIC BALLS TO BUILD YOUR SHAPE RATHER THAN ONE BIG ONE!

FINE BRUSHES WORK BETTER THAN BIG FLAT ONES FOR SCULPTING!

SOMETIMES ITS EASIER TO LET THE ACRYLIC FIRM UP A LITTLE FIRST ON THE NAIL SO YOU CAN MOULD IT PROPERLY

ONCE YOU'VE FINISHED YOUR DESIGN, EMBELLISH WITH CRYSTALS AND PAINT FACES ON YOUR SHAPES!

The pointed nail shape, which is so popular right now, lends itself well to this design. Originally starting out as glossy plain hearts on the nail tip, WAH Girl Kat decided to give them a boost with a baby pink base and a super cute doily effect around the heart. This is a great one for Valentine's day!

YOU WILL NEED
· nail file
· pink polish
· red polish
· red striper
· white nail art pen

LACY HEARTS

STEP 1
File the nail to a pointed tip (this design works best on longer nails). The pointed tip will become the bottom of the heart shape.

STEP 2
Apply a base colour. Pink looks really cute with red but you could try any contrasting colours. Allow to dry.

STEP 3
To create the heart shape, use the red nail polish brush and make a 'V' shape, starting halfway up the nail and brush down to the tip. With a striper dipped into the red polish you can neaten up the shape of the heart. Allow to dry.

STEP 4
For the lacy effect, take a white nail art pen and outline the top of the heart. Use the white outline as your guide and make little loops around the top of the heart.

STEP 5
Finally, use the white nail art pen to make some little dots just above the loops which will give a lovely, lacy finish to the heart.

TOP TIP
ENSURE YOUR WHITE NAIL PEN IS COLD. IF IT'S TOO WARM, IT WILL RUN THICK. ALSO DONT SQUEEZE AS YOU ARE PAINTING. SQUEEZE A LITTLE BIT OUT THEN DRAW WITH THE EXCESS.

WAH GIRL #9

KAT

I'm Kat, London born and bred and a WAH Girl for just over a year now. I went to New York with the girls for a pop-up shop and that trip will probably be my favourite WAH memory. I'd love to do nails for Kirsty Allsop, Kat Slater and Elizabeth Taylor — all fantastic and inspirational women. My fave nails that I've seen at WAH have got to be the My Little Pony nails that Simona did for Loui-Marie for her birthday. They were incredible! My hair is very much inspired by My Little Pony! Bradley at Bleach does it on a regular basis and we've just discovered a dry shampoo with glitter sparkles in it that is totally making me squeal with delight. If I wasn't a WAH Girl I'd probably be a unicorn...

SO YOU WANNA BE A NAIL TECH?

MAKING A LIVING BY SPINNING THE DECKS ALL NIGHT, WHILST LEARNING ALL THERE IS TO KNOW ABOUT NAILS AT SCHOOL ALL DAY, KRISTINE BARLLI IS A WAH GIRL THROUGH AND THROUGH. EMBODYING AMAZING STYLE AND A THIRST FOR KNOWLEDGE, WE LOVE HER FOR HER INFECTIOUS ENTHUSIASM. HERE SHE TALKS ABOUT HER EXPERIENCES AT NAIL SCHOOL AND WHY NAILS ARE AN ART FORM.

Much like the story of WAH, I initially became interested in being a nail tech because getting unique and on-point nails was becoming impossible in New York. With prices on the rise (even in the crummy areas), waiting lists into the three-month mark at the few art-centric calgel spots, and communication breakdowns in regards to my vision, I decided to take the matter into my own hands and enlist in nail tech college, aka NAIL JAIL! This experience has proven to be a *tour de force* of both nail training and comedy gold, in regards to my off-the-wall classmates. Firstly, the experience of soaking off my acrylics in order to participate in class and to abide by the 'no nail enhancements' rule was DEVASTATING! Never have I gone so long without nails. I felt naked and confused but also realised that in this crucial learning period I would have to be the Mother Theresa of nails and sacrifice my own nail game for the sake of others!! This has proven to be an invaluable experience. Understanding the roots and beginnings of nail design is crucial for being able to really take advantage of the new technology and products that are coming out everyday.

If I can DJ all night and come to school all day and do six hours of silk and fiberglass sets (WITH NO AIR BUBBLES!) — whilst the schools spa relaxation CD repeats a Japanese flute version of 'My Heart Will Go On' every hour on the hour — without throwing in the towel, you can too!

We all know nails are an art form, but understanding how and why nail design began is where it all changed for me. Picasso didnt start out as an abstract painter, in fact his early stuff was quite boring and technical. In art school, they push this idea on you with hope you'll understand that learning the technicalities and origins of your trade will help you reach an even higher creative potential, while not losing sight of the original purpose.

Being able to take a client's vision and run with it (without feeling limited as to what you can do), is the best! Nail art has no ceiling. You can truly take any cultural reference point or idea and run with it wherever you want to go. It's sort of like the hunt for records. You can't ever know or have them all, so the joy of the hunt is what keeps you going and learning. With nail art, you can create something nobody else has. You can take the most 'out there' concept or the most simplest, glamorous design (Guy Bourdin Nail shots in French *Vogue*!), and make it feel unique and all your own. Stay hungry, stay creative and never stop taking what you love to do to the next level. Inspiration runs wild when you learn new things and skills so read up!

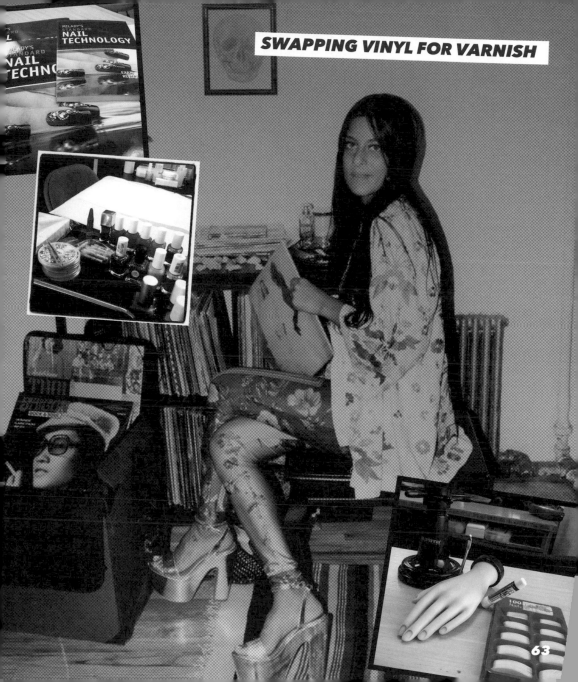

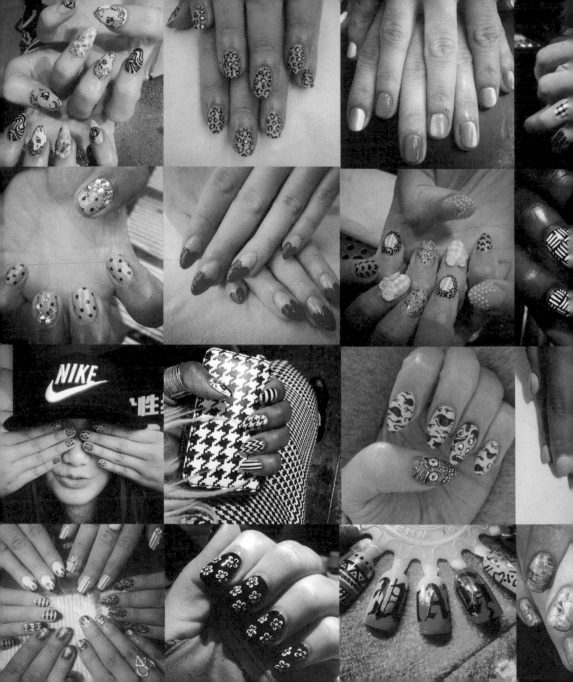

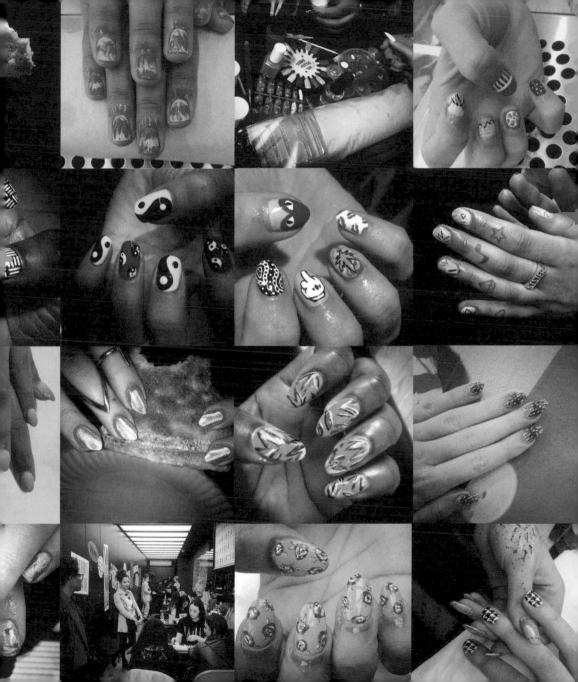

A WAH classic, OG design and favourite amongst all our nail techs. The leopard print design is like a finger print, everyone does it differently but one thing's for sure, it always looks FIYAH! Here we show you a basic version with a simple fade underneath.

YOU WILL NEED
· yellow polish
· orange polish
· pink polish
· purple polish
· black nail pen
· sponge

LEOPARD

STEP 1
Paint your nails in your base colour — here we've done alternate fingers.

STEP 2
Working on one finger at a time, using your second colour, thickly paint about a third of your nail starting from the tip.

STEP 5
Fill in any gaps with semi circles and commas.

STEP 4
Using you nail art pen, start in the centre of the nail with one broken circle/triangle. Using the first circle as a guide work outwards making the shapes smaller.

STEP 3
With your sponge, dab the wet polish down the nail to make a fade. Allow it to dry.

TOP TIP
ENSURE YOUR LEOPARD DESIGN GOES OFF THE NAIL FOR A TRUE PRINT EFFECT.

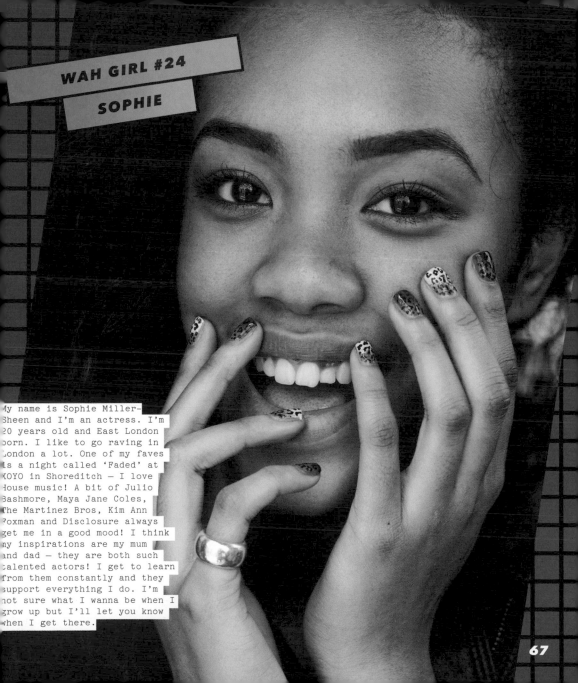

My name is Sophie Miller-
Sheen and I'm an actress. I'm
20 years old and East London
born. I like to go raving in
London a lot. One of my faves
is a night called 'Faded' at
XOYO in Shoreditch — I love
House music! A bit of Julio
Bashmore, Maya Jane Coles,
The Martinez Bros, Kim Ann
Foxman and Disclosure always
get me in a good mood! I think
my inspirations are my mum
and dad — they are both such
talented actors! I get to learn
from them constantly and they
support everything I do. I'm
not sure what I wanna be when I
grow up but I'll let you know
when I get there.

Eye designs are massively popular in the WAH Nails salon, ranging from Turkish evil eyes to gory bloodshot ones. We decided to beautify one of our classics with a Manga-style eye.

YOU WILL NEED
- white striper
- lilac polish
- blue polish
- green polish
- yellow polish
- pink polish
- black nail art pen
- white nail art pen
- black striper

STEP 1
Paint a couple of coats of your base colour.

STEP 2
Using your white striper, paint outlines of your eyes and fill them in. Keep them big and Manga-like!

MANGA EYES

STEP 3
Pick three polishes from the same colour palette and, using a clean striper, paint the iris of the eye using one of them. Use the other two polishes to add flecks in the iris — magical!

STEP 5
Lastly, use your black striper to add full on lashes like you wish your mascara did. Don't forget to topcoat!

STEP 4
Pick up your black pen and draw the eye's pupil. Allow to dry then using a white nail art pen add a little star or heart followed by two smaller white dots for cute light reflections.

TOP TIP
DRAW A FEW MANGA EYES OUT IN YOUR SKETCHBOOK TO GET IT JUST RIGHT. DONT FORGET TO ADD THE WHITE DOTS ON THE IRIS! IT'S WHAT MAKES THE EYE LOOK BIG AND CARTOONY!

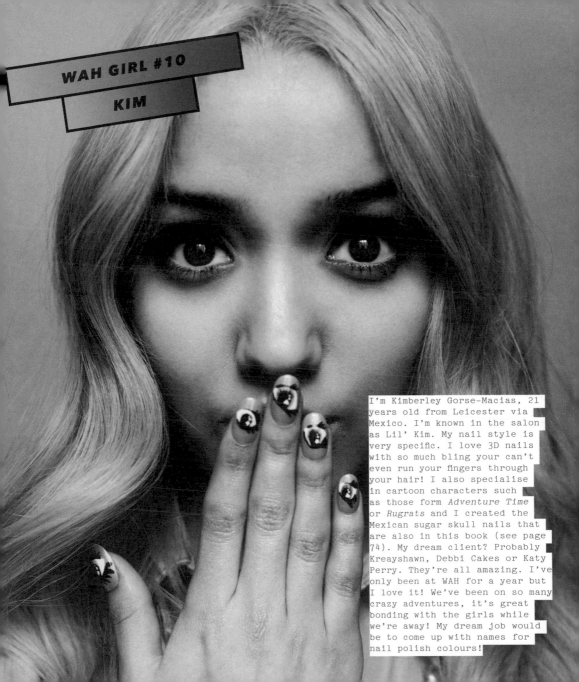

I'm Kimberley Gorse-Macias, 21 years old from Leicester via Mexico. I'm known in the salon as Lil' Kim. My nail style is very specific. I love 3D nails with so much bling your can't even run your fingers through your hair! I also specialise in cartoon characters such as those form *Adventure Time* or *Rugrats* and I created the Mexican sugar skull nails that are also in this book (see page 74). My dream client? Probably Kreayshawn, Debbi Cakes or Katy Perry. They're all amazing. I've only been at WAH for a year but I love it! We've been on so many crazy adventures, it's great bonding with the girls while we're away! My dream job would be to come up with names for nail polish colours!

THE SUPER INTERN

ELLIE HARRY JOINED US LAST SUMMER AS AN INTERN, BEATING A LONG LIST OF WAHNNABES TO ASSIST THE MANAGEMENT. HER ENTHUSIASM, MULTI-TASKING AND TOTAL AWESOMENESS HAVE MADE HER A FULLY-FLEDGED MEMBER OF THE WAH TEAM - THE FIRST EVER INTERN WE HAVE PROMOTED TO EMPLOYEE. READ HER TIPS ON HOW SHE DID IT.

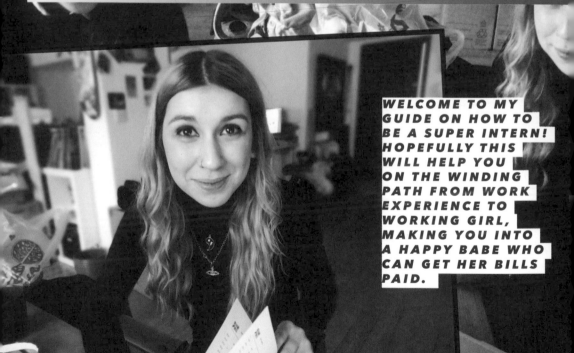

WELCOME TO MY GUIDE ON HOW TO BE A SUPER INTERN! HOPEFULLY THIS WILL HELP YOU ON THE WINDING PATH FROM WORK EXPERIENCE TO WORKING GIRL, MAKING YOU INTO A HAPPY BABE WHO CAN GET HER BILLS PAID.

CONGRATS IF YOU GET A JOB FROM YOUR INTERNSHIP, YOU EARNT IT! SOMETIMES THERE ISN'T ALWAYS A PAYSLIP AT THE END, BUT IF YOU SHOW YOUR BOSS THE TRAITS OPPOSITE YOU'LL WALK OUT WITH A SUPER SHINY REFERENCE WHICH MAY JUST LAND YOU THE JOB YOU WANT... GO GET 'EM.

1 INTERN SOMEWHERE YOU THINK IS RAD

What's the point in interning somewhere you hate? Pointless. I love where I work, and I knew I would as the painting nails half of it was something I chose to do in my spare time anyway. Pick something you like, or a career you see yourself progressing in or gaining something, whether that is just in experience or knowledge. Three very powerful things, I'm sure you'd agree.

2 BE A HELP, NOT A HINDERANCE

More than likely your role as an intern is to help eliminate the jobs which take time, but are easy enough to get through. Don't forget to do stuff (with the help of step 3), as it is super embarrassing when you have to ask what your second task was because you forgot it five mins earlier - or you forgot how to plug in your common sense that morning. Helpful people are kinda the best people, and you want to be the best, right?

3 HAVE A GREAT NOTE BOOK

No doubt you'll be asked to go here to pick up this from that person, and then sent across town to sort that task out. Best to make a load of lists so you know whats happening then nobody will ever know how forgetful you really are. I liked to use scrap pieces of paper which upset Sharma (Queen of the fancy Smythson notebook), so she got me a notebook which makes me look dead organised now.

4 BE A PUMPED VERSION OF JIM CARREY

Nobody wants a grumpy intern, and this internship will be your chance to show your boss why you're defo worth investing time, and later, money in. You know that film *Yes Man*? As much as I hate Jim Carrey I recommend channeling his role and just say yeah to everything that comes your way and enjoy doing it! Twelve-hour days without getting paid might not sound that awesome. However it shows you're dedicated and you'll be rewarded with responsibility — yay!

5 HARD WORK GETS NOTICED, AND PAYS OFF

Check this for a funny story: I broke my leg about a month into my internship and had my crutches and cast for like six months, but I carried on interning, crutches 'n' all. It was a crappy situation that was turned into a win-win — I was occupied, happy and I showed I was pretty willing. You don't need to break your leg to show this, and you may find your internship might be a different environment to WAH. You may be using these tips in a super huge company where you're working alongside ten other interns, which means you have to work hard to stand out. But the main thing — and I don't think I can tell you enough — is to be enthusiastic and determined!

Our little Mexican firecracker, Kim, created these nails and they're pretty much the only requested design on the 'Day of the Dead' festival days. Although intricate, the loops and lacy effects are manageable when you get a rhythm going. Fimo cane flowers can be bought online for a 3D effect but if they're not available you can draw the flowers on instead using a pink nail art pen.

YOU WILL NEED
· white polish
· black striper
· black nail pen
· flower fimo canes
· top coat
· pink nail art pen
· blue nail pen
· gold bullion beads
· Swarovski crystals

STEP 1
Apply your white polish as your base colour.

STEP 2
Using a black striper, make the long line to start the teeth. Using the black nail pen create the scallop design along the black line to create the teeth.

MEXICAN SKULLS

STEP 5
Get creative! Using pens, gold beads and crystals to add different motifs of flowers, hearts and dots to decorate your skulls.

STEP 4
Using pre-sliced flower fimos, stick them on with a topcoat to make the eyes, then add two crystals to the centre of the flowers.

STEP 3
With your black striper draw a small upside down heart for the nose. Start by dotting two black dots and dragging the polish to meet in the middle.

TOP TIP
WHEN PLACING THE TINY GOLD BEADS, DAB YOUR AREA WITH TOPCOAT THEN WORK SUPER FAST PICKING THEM UP WITH A COCKTAIL STICK.

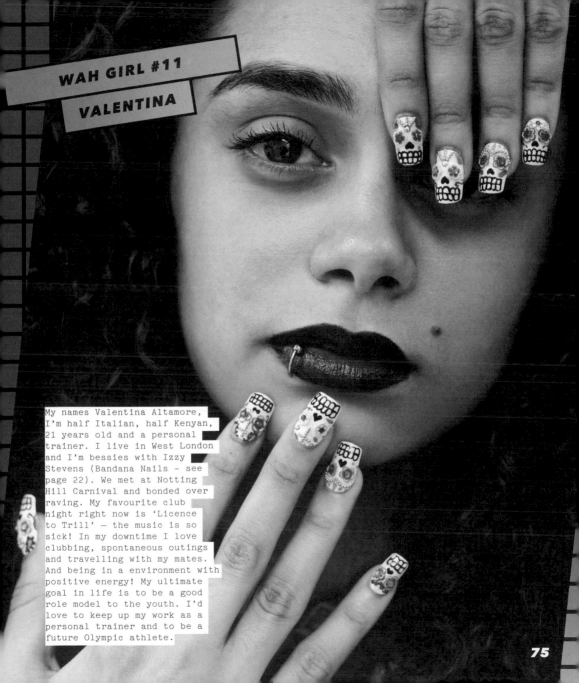

My names Valentina Altamore, I'm half Italian, half Kenyan, 21 years old and a personal trainer. I live in West London and I'm bessies with Izzy Stevens (Bandana Nails - see page 22). We met at Notting Hill Carnival and bonded over raving. My favourite club night right now is 'Licence to Trill' — the music is so sick! In my downtime I love clubbing, spontaneous outings and travelling with my mates. And being in a environment with positive energy! My ultimate goal in life is to be a good role model to the youth. I'd love to keep up my work as a personal trainer and to be a future Olympic athlete.

GHETTO NAILZ

ALTHOUGH RELATIVE NEWCOMERS TO THE SCENE, YOU'D BE FORGIVEN FOR THINKING THAT NAILS WAS IN THE BLOOD OF THESE LATIN LADIES. HAILING FROM MADRID, WITH OUTPOSTS IN BRAZIL AND OTHER PARTS OF SPAIN, GHETTO NAILZ IS A TIGHT CREW WITH A WHOLE LOTTA STYLE. FOUNDER, JESSICA ABOU NASSAR, TELLS US ABOUT HOW SHE GOT STARTED AND HER PLANS FOR NAIL DOMINATION

WHAT WOULD YOU TELL YOUR 16-YEAR-OLD SELF?

To stop thinking about boys and partying and paint nails instead!

FAVE TUNE TO PLAY IN SALON?

Too $hort - 'Money In The Ghetto'

DREAM CLIENT?

Grace Jones!

GHETTO NAILZ ARE:
JESSICA ABOU NASSAR, 26, HALF BELGIAN HALF LEBANESE (FOUNDER)
ANDREA DELGADO, 24, PONFERRADA, NORTH SPAIN (CO-FOUNDER)
LAURA TUÑON MENDEZ, 26, PONFERRADA, NORTH SPAIN (CO-FOUNDER)
LUZ BELENGUER, 28, CADIZ, SOUTH SPAIN
ZAIDA ELCUAZ, 30, PAMPLONA, NORTH SPAIN
LIGIA SOLER, 23, FLORIANOPOLIS, BRAZIL
CAMILA FONTOURA, 28, FLORIANOPOLIS, BRAZIL

We all do nails for Ghetto Nailz, then we each do our own little things. Jessica has a bikini and spandex label called Soda Pop, for which she works on at the same time as Ghetto Nailz, and she sometimes DJs with Andrea who is also a stylist. Then Laura is a stylist for TV ads, fashion and music videos, and girlfriend of one of the Zombie kids (heheh). Luz works as a club promoter and makes fetish leather accessories and fun goodies. Zaida is working on her first five-panel caps collection called Chamberi. Ligia and Camila are our Brazilian Ghetto girlz who are working between their hometown Florianopolis, Sao Paolo and Rio de Janeiro, expanding Ghetto Nailz across the country. We would like to open more franchises across Latin America in the future. Its a crazy mix but it works.

My nail art obsession began in 2010 when I went to New York for three months to intern at fashion designers studio Threeasfour. I was living in Washington Heights, the Dominican hood in the north of Manhattan, on 188st on St Nicholas Avenue. This street was packed with nail salons and barber shops, so I thought to myself, 'I really want to know what it's like to live with super long ghetto nails like the cashiers in the supermarket'. I was amazed by how they did things with those massive nails, and I loved all the brightly coloured designs. So I was interning as a pattern designer with these huge nails and actually managed to do things, and could even sew by the end of the three months!

I came back to Madrid and went to the regular nail salons and they freaked out. They had never seen such things. They refused to design whatever I asked for, they only wanted to do boring stuff. So a year later, after finishing an internship, at Loewe, I decided to set this Ghetto Nailz up with my friends, and we have

been so lucky that it actually works and people appreciate nail art in Spain now. We started out just practising nail art on our friends and before we knew it, Spanish fashion magazines, newspapers and television kept contacting us! We decided to take it seriously and do an acrylic and gel sculpting course to learn how to do proper nail extensions.

We get inspiration from anything fun, colourful, fresh, sexy, bright, eye-catching, tasty and delightful. Our favourite designs are the 80s/90s inspired patterns, fast food nails, cupcakes, ice-cream, tropical, fruity designs and geometry. I think the best advice I can give to aspiring nail techs is to practice day and night and pursue your dreams until you achieve them. It is possible to work and make a living doing arty and pretty things!

The goal with our company is to expand to a couple more countries in Europe, to Latin America and then eventually to the USA — as our style is very much inspired by the California-NY scene, and we have a lot of followers in the Americas thanks to Instagram. It will not only be a nail salon, but a store where you can buy wicked clothes, listen to cool music and see art exhibitions. We are opening the first Ghetto store in Madrid where you will be able to get your nails done while sipping on a fruit juice, get the latest trends in fashion, listen to some good music and have the whole Ghetto Girl experience. We organise a flea market once a month called Ghetto Weekend where all our designer friends and vintage shops from Malasaña area reunite. Then at Zombie Club we throw Ghetto Party once a month, where we make you dance till 6am non-stop!!

We are constantly thinking of fun things to do and all this thanks to painting nails. Nailpower!

JESSI POP
ANDRE
LUZ
LAURA

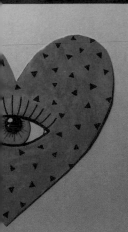

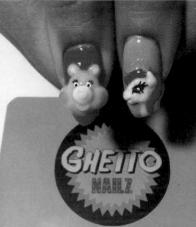

GHETTO NAILZ

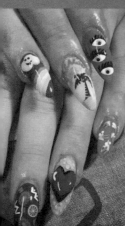
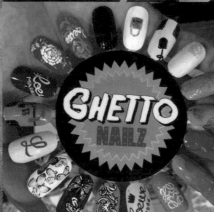

GHETTO NAILZ

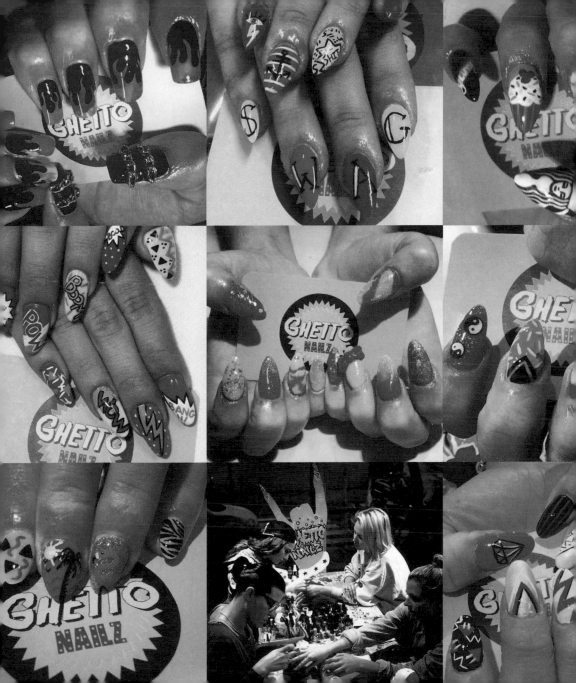

We love Pendleton clothing and blankets! The traditional Indian woven fabric patterns lend themselves perfectly to nail designs with their bright colours and bold prints. Choose an ombre of colours from a simial family, but be sure to include a turquoise colour for a true Native American feel.

STEP 1
Paint your base colour nude and allow it to dry. Starting from the middle of the nail, make horizontal lines using your coloured polishes. Work your way through the spectrum of colours so that they mirror each other from the top and bottom of the nail.

YOU WILL NEED
· nude nail polish
. yellow polish
· red polish
· purple polish
· turquoise polish
· black striper

NAVAJO

STEP 2
For the Native American style designs you will need a black striper. Using the background stripes as a guideline, make little triangle shapes starting from the middle of the nail and working your way out.

STEP 5
Repeat similar, but designs on each nail. Just make sure they're symmetrical.

STEP 4
From the corners of each nail make thin 'V' shapes which frame the nail and black them out with the striper.

STEP 3
Emphasise the triangles by blacking the spaces between each one.

THE FULL SET!

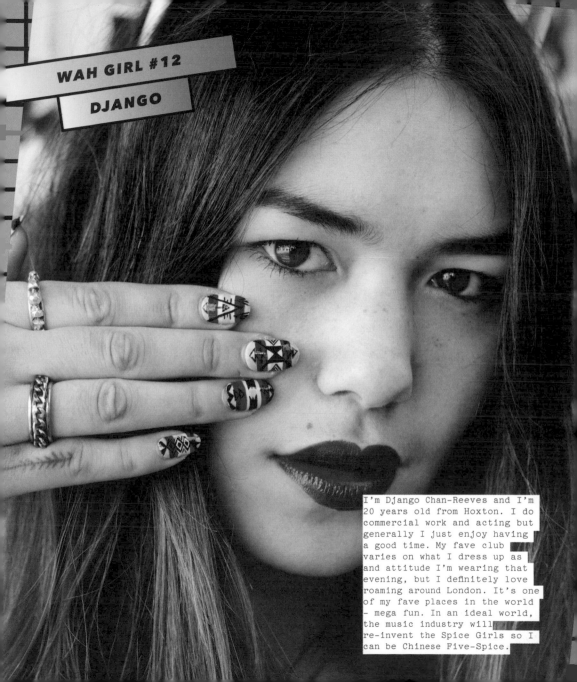

WAH GIRL #12

DJANGO

I'm Django Chan-Reeves and I'm 20 years old from Hoxton. I do commercial work and acting but generally I just enjoy having a good time. My fave club varies on what I dress up as and attitude I'm wearing that evening, but I definitely love roaming around London. It's one of my fave places in the world - mega fun. In an ideal world, the music industry will re-invent the Spice Girls so I can be Chinese Five-Spice.

CREATE YOR OWN DECALS

FOR PHOTO-FINISH NAIL ART, DECALS ARE A GREAT WAY TO GET THAT PICTURE PERFECT IMAGE WHEN NAIL ART PENS JUST WON'T DO. OUR NYC NAIL GIRL CHRISTINA RINALDI SHOWS US HOW! SURE, IT'S TIME CONSUMING AND A LITTLE FIDDLY BUT THE RESULTS ARE AMAZING! THESE NAILS ARE BEST DONE WITH YOUR GIRLFRIENDS ON A SLEEPOVER - FORGET SCRAPBOOKING, WORK ON MAKING COLLAGES ON YOUR NAILS INSTEAD!

Our LA babe, Camille Garmendia wanted to go for a Chola look to represent her El Salvadorian roots. We found various imagery on the internet and mixed it in with some hand-painted nail art. Decals work best when you use lots of different images, text or different sections of the same print. Raid your local art store for supplies. We'll show you how to do a basic decal so then you can go wild with your own design!

YOU WILL NEED

- rubbing Alcohol (70 per cent Isopropyl alcohol)
- small finger bowl or plastic cup (for alcohol)
- colour photocopy designs
- white polish
- topcoat
- tweezers
- scissors

THANKS CHRISTINA! CHECK OUT HER AMAZING NAIL WORK AT PRIMACREATIVE.COM

STEP 1

Create an A4 Photoshop document and arrange the design you want multiple times, in various sizes — you never know how you want to crop it, and how it'll fit on each finger. Make sure to print text and designs BACKWARDS.

STEP 2

Either print this from a laser printer OR print on inkjet and get a colour photocopy made at your local copy shop.

STEP 3

Paint a thin coat of white paint on the nail. Make sure nail is COMPLETELY 100 per cent DRY before continuing.

STEP 4

Cut out the design at the desired size to fit the nail.

STEP 5

Soak design in cup/bowl of alcohol for 5-8 seconds

STEP 6

Lay your design ink-side down onto the nail. Press and hold for 5-10 seconds, pressing on all corners of the nail and design. Take the end of your tweezers and press across the design to ensure it's transferring.

STEP 7

DON'T FORGET THAT ANY TEXT SHOULD BE WRITTEN IN REVERSE!

Begin to pull up the paper slowly so that nothing but the ink is left on the nail. If you see bits of the paper are getting stuck, use more alcohol to rinse the paper fibers off. Cover with topcoat for enhanced saturation and gloss.

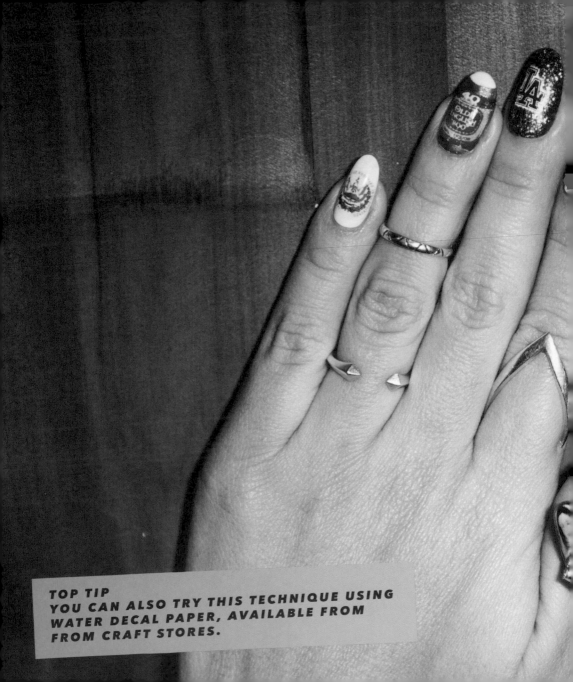

TOP TIP
YOU CAN ALSO TRY THIS TECHNIQUE USING
WATER DECAL PAPER, AVAILABLE FROM
FROM CRAFT STORES.

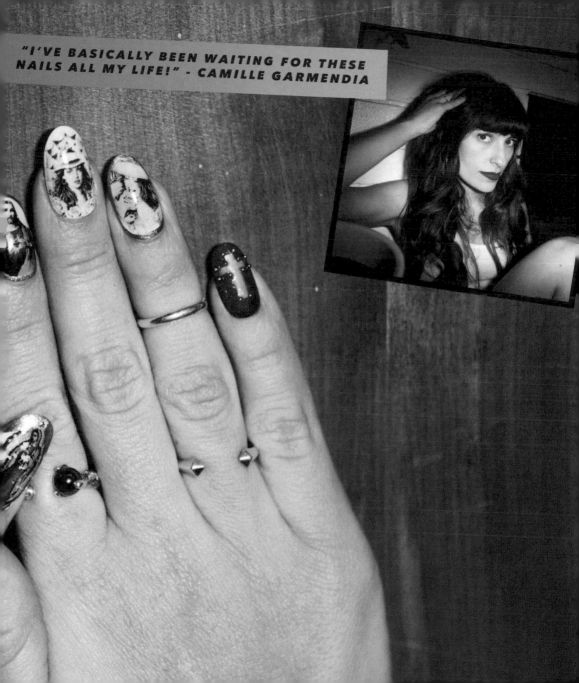

Originating from India via a small town in Scotland, the Paisley design is an intricate but beautiful print on your nails. Take inspiration from the 1970s with a muted colour palette, or go bold with white and blue.

YOU WILL NEED
· purple nail polish
· white nail pen

PAISLEY

STEP 1
Paint your base colour purple and allow to dry.

STEP 2
Using your nail pen, paint a large teardrop shape in a different place on each nail. Add two smaller teardrop shapes coming off the nail.

STEP 5
Add dots and small commas all over the nail for background effect.

STEP 3
Add a smaller teardrop shape inside the large ones. Some can be solid, some can be outlines.

STEP 4
Outline each teardrop with loops and dots.

TOP TIP
THE POLISH IN WHITE NAIL PENS CAN BE A THICKER TEXTURE. USE A LIGHT BACKGROUND WITH BLACK NAIL PEN IF YOU ARE FINDING YOUR DESIGN IS TOO BLOBBY!

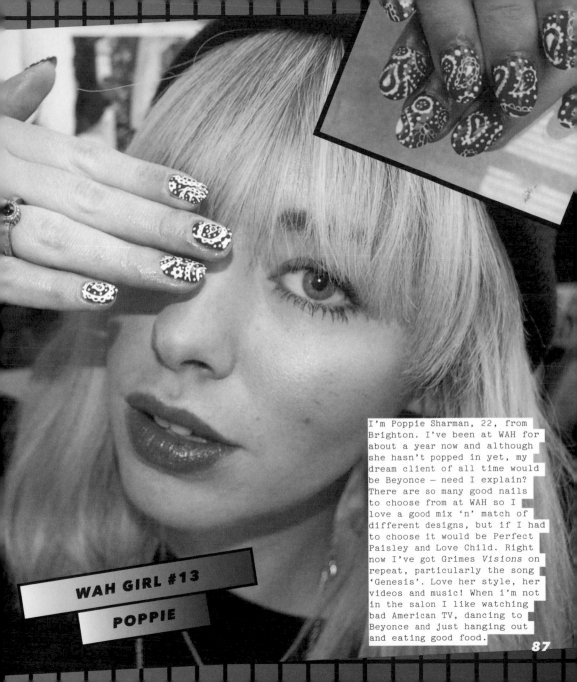

I'm Poppie Sharman, 22, from Brighton. I've been at WAH for about a year now and although she hasn't popped in yet, my dream client of all time would be Beyonce — need I explain? There are so many good nails to choose from at WAH so I love a good mix 'n' match of different designs, but if I had to choose it would be Perfect Paisley and Love Child. Right now I've got Grimes *Visions* on repeat, particularly the song 'Genesis'. Love her style, her videos and music! When i'm not in the salon I like watching bad American TV, dancing to Beyonce and just hanging out and eating good food.

WAH GIRL #13

POPPIE

THE MUSHPIT

THE WAH EMPIRE STARTED AS A HUMBLED PHOTOCOPIED FANZINE ON COOL WOMEN WE LOVED, SO IT SEEMS ONLY NATURAL THAT WAH JUNIOR, CHARLOTTE ROBERTS, WOULD TAKE THE BATON TO WORK ON HER OWN FANZINE WITH HER BFF BERTIE BRANDES. A MIX OF TEEN MAGAZINE NOSTALGIA AND INSPIRED FASHION, THE MUSHPIT IS ONE OF THE FUNNEST FANZINES AROUND RIGHT NOW. THEY'VE GONE FROM STYLING SHOOTS IN THEIR BEDROOM TO STYLING FOR BRANDS AND MAGS. HERE SHE TELLS US HOW SHE GOT STARTED.

We are Charlotte Roberts and Bertie Brandes, both aged 23 years old. We were born in North London and migrated East after leaving school. We decided to make our own fanzine cos we were bored and frustrated with the glossies, which just had no relevance to anything we were doing or interested in. We wanted to write in a way that our friends would recognise about things that actually happened, so we just did it. That's why we talk about awkward dates, boyfriend problems and horrible breakups, alongside fashion stories shot by our favourite photographers and stylists with beautiful, smart girls and boys we know and love! *The Mushpit* is definitely an attitude manifest in a magazine: it's ok to not have all your life together and to still be figuring stuff out in your twenties. That's the most fun (and most agonising) part of being young. Embrace it!

We started putting bits together when we lived in Dalston, in summer 2011. We were looking through old zines and amazing magazines like *Cheap Date* (which is our ultimate favourite — please make another one?!), and were like 'we can totally make our own'. We started mucking about on InDesign, begging for advice from much smarter people and spending our entire student loans on getting it printed. We made about a 100 copies of issue one, and then held the funnest party ever at The Alibi in Dalston, East London, to make some of the money back. We got totally hooked on editing, commissioning, and being broke, so we just kept going and going, and now we're on issue five.

Our playlist when we're making *The Mushpit* includes Britney (obviously), Justified, Spice Girls, Red Hot Chilli Peppers, Ja Rule, Courtney Love, Nirvana. CRUSH! As fun as it is we have had some struggles. It's hard having literally no concept of graphic design, and a lot of people have a problem with our art direction. But that's always been part of the appeal; we're making a 21st century 'zine. So using InDesign in the cut and paste way that people used paper and collage 20 years ago, makes a lot of sense. Sure, we might not know exactly what we're doing but it works for our fans, and (we hope) that the kind of aesthetic naivety is part of the charm.

Our inspiration? Poundstretcher. Shops with puns in the name (Curl Up and Dry or Brash and Sassy has to be our favourite). You'll see that thriftiness reflected in our shoot titles, and the accessories we shoot with. It's all about getting glam and having enough money left over for three WKD's and an eggs benedict (and an Oyster card, and just general living). We also are super inspired by the amazing girls around us, be they stylists, writers or agony aunts. We also love *Rookie Mag* and old *Teen Vogue*, but who doesn't?

Our plans for the future? *The Mushpit* domination! We want to have worldwide distribution and eventually set up properly online. We want to work with other magazines, create content with people we love and respect, and get a new pair of shoes each! Our advice to any aspiring 'zine makers is to get on and do it. It's not that hard and it's the funnest thing ever. Get your friends involved, and enjoy the freedom of being able to do whatever you want without worrying about any of the boring stuff like pleasing advertisers. Throw parties to make money, send it out to your idols and believe that if you're putting something out there, great things will come back to you too. Good luck!

EMAIL INFO@THEMUSHPIT.COM FOR MORE INFORMATION, OR TO CONTRIBUTE. WE LOVE YOU!

Here at WAH we are all about super island vibes! Everything about the salon is tropical, from the colour palette to our original designs. Grab your rum punch and get tropical with this palm leaf print.

YOU WILL NEED
· neon green polish
· black striper

STEP 1
Paint your base colour neon green.

STEP 2
Using your black striper, draw a diagonal line coming from the bottom right of your nail then gently press the tip of your brush along the line to make small feather-like strokes.

PALM LEAF

STEP 5
Paint two smaller mini leaves coming off the side of the nail.

STEP 4
Repeat steps 2-3 to create another palm leaf opposite your first one.

STEP 3
Paint four more leaves coming off the branch.

TOP TIP
IF YOUR STRIPER BRUSH HAS A WAYWARD BRISTLE THIS CAN RUIN YOUR DESIGN. KEEP YOUR STRIPER CLEAN AND SNIP OFF ANY LOOSE BRISTLES WITH NAIL SCISSORS.

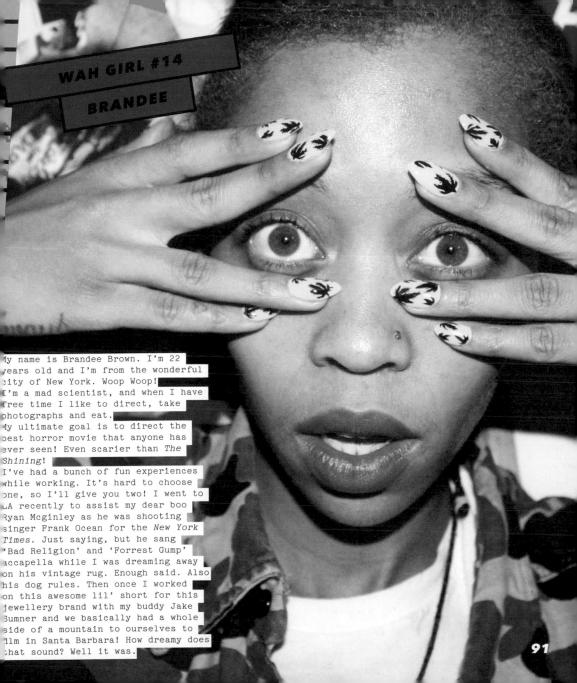

My name is Brandee Brown. I'm 22 years old and I'm from the wonderful city of New York. Woop Woop! I'm a mad scientist, and when I have free time I like to direct, take photographs and eat.

My ultimate goal is to direct the best horror movie that anyone has ever seen! Even scarier than *The Shining*!

I've had a bunch of fun experiences while working. It's hard to choose one, so I'll give you two! I went to LA recently to assist my dear boo Ryan Mcginley as he was shooting singer Frank Ocean for the *New York Times*. Just saying, but he sang 'Bad Religion' and 'Forrest Gump' accapella while I was dreaming away on his vintage rug. Enough said. Also his dog rules. Then once I worked on this awesome lil' short for this jewellery brand with my buddy Jake Sumner and we basically had a whole side of a mountain to ourselves to film in Santa Barbara! How dreamy does that sound? Well it was.

SEIZE T

Animal prints are the most fun to do on nails and python skin is definitely one for the sophisticated! This design relies on iridescent and shimmery shades to get a real scaly feel. Go for two or three different shades of the same colour and get your sponge at the ready.

STEP 1
Paint your base of light green iridescent polish.

YOU WILL NEED
· light green iridescent polish
· dark green shimmer polish
· black nail art pen

STEP 2
Paint a little dark green polish onto your sponge and dab a line down the centre of each nail.

PYTHON SKIN

STEP 3
Using your black nail pen draw a loose zig-zag down the nail.

STEP 5
Repeat on the other side of the nail until your whole nail is covered.

STEP 4
Using the zig-zag line as your guide, draw small semi-circle zig-zags or scallops, going smaller as you reach the edge of the nail.

TOP TIP
WORK ON GETTING A SUPER THIN LINE WITH YOUR NAIL ART PEN. USE IT TOO THICKLY AND IT WILL GO BLOBBY!

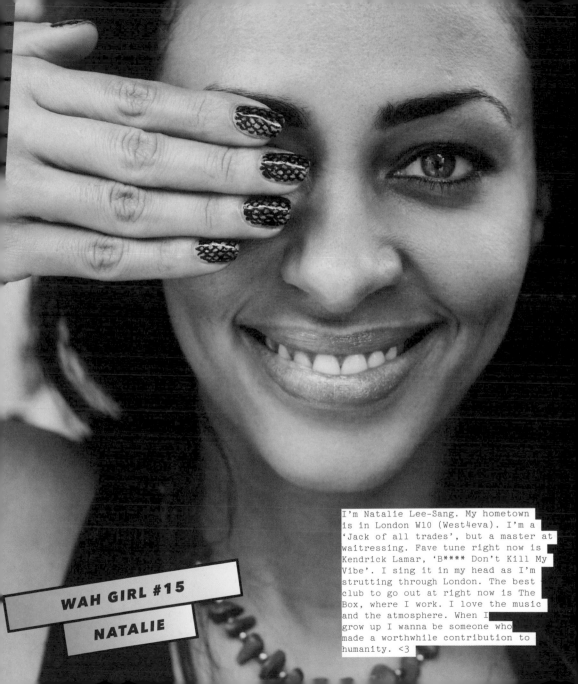

WAH GIRL #15

NATALIE

I'm Natalie Lee-Sang. My hometown is in London W10 (West4eva). I'm a 'Jack of all trades', but a master at waitressing. Fave tune right now is Kendrick Lamar, 'B**** Don't Kill My Vibe'. I sing it in my head as I'm strutting through London. The best club to go out at right now is The Box, where I work. I love the music and the atmosphere. When I grow up I wanna be someone who made a worthwhile contribution to humanity. <3

HOW TO BE ALONE

PHOEBE LOVATT IS SMART, SEXY AND FUNNY, BUT THE
QUALITY SHE CARRIES THAT MAKES HER THE ULTIMATE WAH
GIRL, IS SELF ASSURANCE. SHE WALKS WITH THE AIR OF
SOMEONE HAPPY IN THEIR OWN SKIN. SHE LET US INTO A
LITTLE SECRET: IT COMES FROM BEING ABLE TO BE ALONE.
WHEN YOU'RE COMORTABLE BEING A LONE SOLDIER, YOU CAN
DO SO MUCH MORE. HERE SHE TELLS US HOW!

We all like to roll deep in a group of girls who have our backs, know our secrets, and stop us sending late-night text messages that we'll almost certainly regret in the morning. Life would be no fun without your crew. But there are times in life when it's essential to be alone - whether you want to be or not - and it's important that you know how to do it, and do it well.

First off, hold your head up high. Despite the subliminal messaging you've absorbed from a million high school movies, there is no shame in being 'Miss Solo Dolo'. Any outdated notions you have that loners are losers need to be left behind. Being an independent woman is about so much more than paying your own bills. Grown women know how to take care of themselves, handle their own business, and — crucially — enjoy their own company.

Not convinced? Spend a few hours doing one of the countless things that are better on your own, anyway. These include, but are not limited to getting lost in an inspiring book; curling up smack bang in the middle of a freshly-made double bed; daydreaming; plotting world domination (for more ideas, check the list on the next page). And if you feel you look pathetic when engaging in solo activities, then answer me this: Can you think of anything more impossibly glamorous than a gorgeous, confident woman kicking it outside a chic café with nothing more than a glass of champagne for company? Nah, me neither.

A space to develop your own thoughts and ideas without the opinions of others clouding your world view. You can meet new people who don't know — or need to know — your entire life history. You can go wherever you want, whenever you want, and do whatever you want when you get there. To learn to be alone is to know true freedom.

There are, of course, certain situations where being alone isn't desirable, or safe: dark alleyways, skeezy dives, hotel bars... (there's a certain type of lady who hangs around hotel bars on her own, and you don't want to be mistaken for her). I'm not advocating a life spent as a hermit — family is everything, friends are happiness, and love is what makes the world go 'round, after all — but a little alone time is rarely ever a bad idea.

Cheesy but true: the most important relationship you'll ever have is with yourself So learn to live with you — just you — and you'll find you've got an inbuilt, ride or die, best girlfriend for life. What could be less lonely than that?

THINGS TO DO ALONE

1. Catch an afternoon movie in a near-empty cinema.

2. Create – The ability to use solitude constructively is a shared trait of all highly creative people. So draw, write, paint, design a website, take photos, write a song.... You get the idea.

3. Make your favourite meal in a perfect portion for one. Sit down to enjoy its taste and individual-sized appeal.

4. Pull on your tracksuit, prop yourself up in bed with your laptop, and enjoy an uninterrupted Netflix marathon.

5. Go shopping. One of the great myths of modern society is that shopping with your friends is brilliant fun. It's not: you have to go in shops you hate, wait around in stuffy changing rooms, and deal with the very real possibility that you'll all want to buy the same stuff. Try it alone and experience a retail therapy buzz of previously unknown proportions.

6. Make a moodboard. Take a pile of magazines and tear out all the images that inspire you and display them somewhere prominent for an instant daily uplift.

7. Have an adventure. Jump on a bus and visit a part of town you never normally visit, or take a cheap flight to a city you've never seen. Sit outside a café and watch the world go by. Enjoy your new persona as an international woman of mystery.

8. Clear out your wardrobe, clean up your bedroom, organise your bookshelf. Crossing all those tedious tasks off your to-do list in your own time will free you up for having more fun with others.

9. Put on a boxset and paint your nails. Slowly and carefully, and sit very still and allow them to dry. No rushing from the salon to the meeting to the doctors. Just devote ample time to do the design you want.

10. Appreciate the luxury of solitude. There will probably be a time in your life when kids and partners and work and pets will crowd every waking moment of your day. Alone time will seem like a delicious and distant memory. Savour it while you can!

99

Got something to say? Say it with your nails! There are many types of writing you can do on your nails, but we think script writing is cool as it connects all your nails together to form a message. We did these nails for our friend Ashley William's debut collection at London Fashion Week. She wanted to CELEBRATE so we whipped these up for her. One or two letters per nail works well and it's a good chance to get practising with your nail art pen.

STEP 1
On a piece of paper write out your word in joined up writing. Add flourishes to the end of letters to add to the effect.

YOU WILL NEED
· blue polish
· white nail pen

SCRIPT WRITING

STEP 2
Using your white nail pen, paint a large, cursive 'C' on your thumb nail. Make sure the end of the letter comes off the nail.

STEP 5
Allow to dry fully before top coating. As the white will be thick, you don't want to ruin your design by dragging your polish through it.

STEP 4
Repeat until you have finished your word 'CELEBRATE' ensure the words starts off the nail and finishes off the nail.

STEP 3
Starting from the edge of the nail draw a lower case 'e' on the left side of the nail and flow it around to an 'l' Make sure the 'l' comes off the nail.

celebrate

TOP TIP
PRACTICE YOUR WORD USING YOUR NAIL PEN ON A PIECE OF PAPER BEFORE STARTING.

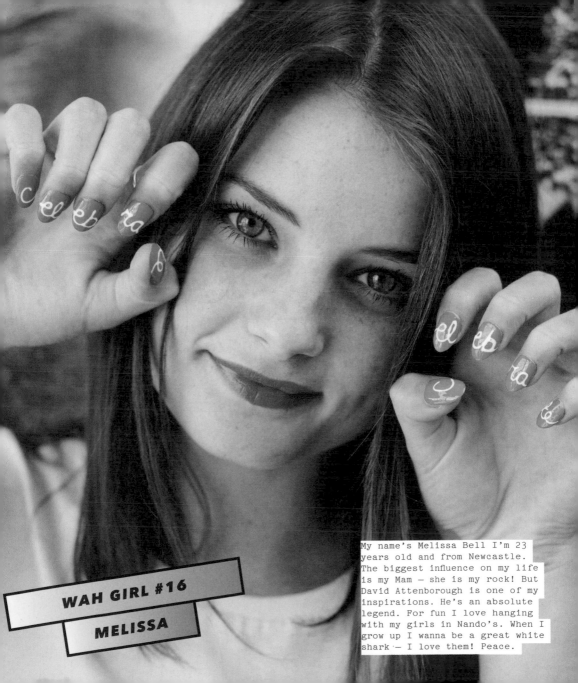

WAH GIRL #16

MELISSA

My name's Melissa Bell I'm 23 years old and from Newcastle. The biggest influence on my life is my Mam — she is my rock! But David Attenborough is one of my inspirations. He's an absolute legend. For fun I love hanging with my girls in Nando's. When I grow up I wanna be a great white shark — I love them! Peace.

BLEACH LONDON

BLEACH LONDON ARE OUR SISTERS IN BEAUTY. WHAT WE DO FOR NAILS, THEY DO FOR HAIR, MAKING THE WORLD A BRIGHTER, PRETTIER PLACE WITH THEIR DIP DYES, HAIR STENCILS AND TIE DYE COLOUR JOBS. CREATIVE DIRECTOR ALEX BROWNSELL LEADS THE PACK WHEN IT COMES TO HAIR TRENDS, BUT HERE SHE TELLS US THE BASICS ON LOOKING AFTER YOUR NEWLY BLEACHED HAIR.

DO

DON'T

Get down to the salon every four to six weeks for your roots to be bleached.

Don't wait too long to get your roots re-done - your scalp generates heat which lifts your hair to a clean, white colour for the first half an inch. If you leave it too long you'll get a brassy band and need to bleach twice, causing sprouty tufts.

Make sure your hair is at optimum health by using hair masks two weeks prior to your colour treatment, but avoid washing two days before as this makes your scalp over-sensitive.

Put strain on your hair by dyeing it in bad condition or when your scalp is over-sensitive from washing.

Get a trim every eight weeks to refresh the cuticle, and keep your hair looking healthy.

Leave hair too long before your next trim because once the hairs split they make friends.

Alternate super-rich treatments with lighter shampoos and conditioners.

Use protein treatments more than once a week - they can over keratinise your hair, causing it to be dry, brittle and weighed down by the moisture.

Sleep on a silk pillowcase - this will cause your hair less stress and friction.

Sleep on wet hair - your hair will tangle and you will wake up with birds nest syndrome.

Brush your hair often using a Tangle Teezer or Mason Pearson bristle brush.

Use a cheap, hard-bristled brush that will be aggressive on your hair.

Be patient, and speak to your stylist about how best to embrace a really nice tone that's achievable in your first sitting.

Be disappointed if your colour correction isn't achieved first time - it normally takes a few sessions to reach the perfect result.

LIFE'S A BLEACH

AND THEN YOU DYE

BLEACH

Cute and preppy, sneaker nails are so simple yet effective. Pick bold primary colours or try a fade underneath for a twist.

STEP 1
Paint on your base colours, do every nail different or keep them all the same. It's up to you!

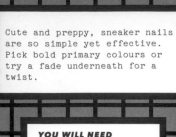

THIS IS A GREAT ONE FOR SHORT NAILS!

STEP 2
Using a white polish and your striper do an upside down half moon at the bottom of your nail.

YOU WILL NEED
· red polish
· yellow polish
· green polish
· blue polish
· white polish
· black striper
. black nail pen

SNEAKER

STEP 5
Using a black striper, paint a smile shape line from one side of your nail to the other (on top of your white half moon), just a little bit up from the bottom of your nail. Don't forget to top coat!

STEP 3
Still using your striper paint on the laces. Start with the line at the top then the two crosses underneath.

STEP 4
Next, use your black pen to dot on your lace holes at the end of each lace line. The black dots should all line up on each side.

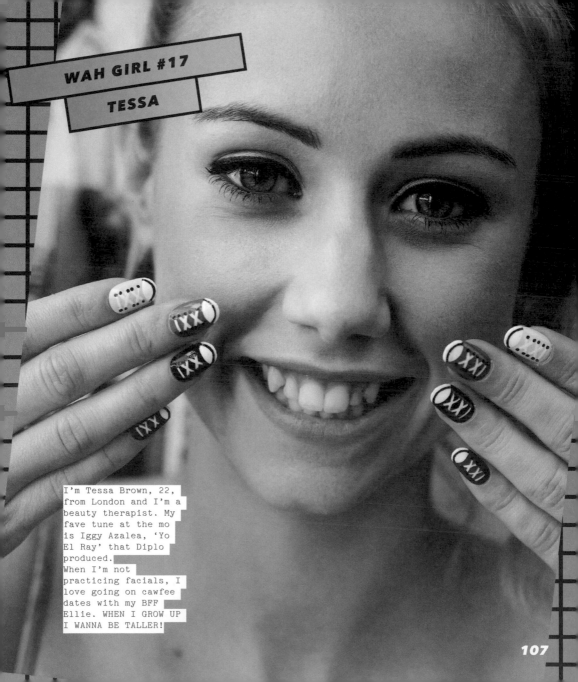

I'm Tessa Brown, 22, from London and I'm a beauty therapist. My fave tune at the mo is Iggy Azalea, 'Yo El Ray' that Diplo produced.
When I'm not practicing facials, I love going on cawfee dates with my BFF Ellie. WHEN I GROW UP I WANNA BE TALLER!

WAH STYLE COMMANDMENTS

LOOKING GOOD IS ALL IN THE MIND. FASHION COMES AND GOES, BUT TRUE STYLE IS TIMELESS. FOLLOW OUR ULTIMATE COMMANDMENTS AS THE GUIDE TO DRESSING LIKE A WAH BABE

1

THOU SHALT FIND YOUR PERFECT A LITTLE BLACK DRESS (AKA THE LBD)

Neneh Cherry had it right. A sexy black dress, truck loads of gold and the right attitude will get you anywhere. This is a total wardrobe workhouse. Find one that is sexy, but not too sexy, formal enough to wear to dinner, but casual enough to wear with sandals to the market. Spend money on this piece. It will be your best friend for decades.

2

THOU SHALT NOT BE AFRAID TO DRESS LIKE A BOY

Skirts and heels are sexy, but so is a tank top and baggy trousers. It's ultimately your confidence that carries you so don't be afraid to raid your boyfriend's wardrobe once in a while.

3

THOU SHALT KEEP THE CLASSICS

Some things never go out of style. Classics like a leather jacket, a tartan skirt, camo pants, Aran jumpers, blue jeans, a white shirt, a black mini skirt and black boots will always be in style. Sure, trends come and go and its nice to be cool and relevant, but use the classics as your wardrobe foundation at your'll always be at the forefront of fashion.

4

THOU SHALT GATHER SHINY ACCESSORIES IN TRUE MAGPIE STYLE

The magpie bird is attracted to anything shiny and twinkling, and well, so are we. If you're wearing a particularly plain outfit, it can always be dressed up with your staple accessories in neons, holographics and general shiny, printed, sparkly things. You can never have too much iridescence when it comes to accessories.

5

THOU SHALT OWN A RED LIPSTICK

There is a red out there for everyone and there's no better outfit pick-me-up than a slick of red lipstick. Our fave is 'Ruby Woo' by MAC. It doesn't move. Ever.

6

THOU SHALT UNDERSTAND THY BODY SHAPE AND CLOTHE IT APPROPRIATELY

Some people are curvy, some are skinny, some are tall and some are short. That's just the way it is, so understand your shape and dress to suit. Don't try and squeeze yourself into drainpipe jeans if you've got an ass like Beyoncé! Embrace your ass and give it a sculpting skirt instead. Once you appreciate your shape, you'll always look good.

7

THOU SHALT UNDERSTAND THAT EXPENSIVE IS A STATE OF MIND

Dressing head-to-toe designer doesn't make you stylish. Carry your thrift store clothes with an #expensive attitude and you'll be winning every day.

8

THOU SHALT KNOW THAT OPPOSITES ATTRACT

Wearing a cashmere sweater? Team it with PVC trousers. Channelling a streetwear look? Throw some Céline into the mix. Our ultimate mantra is opposites attract. A mix of high and low, print and pattern, nude and neon... all those things that seemingly clash, to us, make a perfect outfit.

9

THOU SHALT GET INSPIRED

Don't look in today's magazines and expect to find anything original. Look for your pop culture fashion alter ego and channel it. Ours ranges from all our favourite icons: Madonna, Britney, Neneh Cherry, Penelope Cruz, Lil' Kim, Beyoncé, Courtney Love, Kathleen Hanna, Foxy Brown, Naomi, Kate, Cindy, Kristy and Linda. Sometimes we make scrapbooks of inspiring style. They're not iconic for nothing.

10

THOU SHALT WEAR YOUR CONFIDENCE, EFFORTLESSLY

All the money in the world can't buy the look of confidence. No matter what you are wearing, this should be the accessory to shine through. Everyone has something special about them. It may be something physical — eyes, hair, skin — or it may be something inside — the way you can make someone feel, a special skill or talent. Know what's special about you and use that knnowledge to make you feel good about yourself every day. You know that girl who walks into the room, who is sure of herself, knows her place in the world and has an easy, effortless style? Well thats you! You are amazing!

For those who don't have an airbrush machine at home, it's still totally possible to create splatter and spray look nails with this easy design. Neon colours look great. Just ensure each layer of colour dries throughly before sponging the second one one.

YOU WILL NEED
· white polish
· yellow polish
· sponge
· clean striper brush
· pink polish
· black polish

SPLATTER

STEP 1
Paint your nail with the white base colour.

STEP 2
Paint a little yellow polish on your sponge and dab a spot on your nail.

STEP 5
Repeat with the black.

STEP 4
Repeat using a pink colour.

STEP 3
Using your clean striper brush, dip into the same yellow polish colour and let the polish gently drip from the sponge spot on your nail.

TOP TIP
START WITH THE LIGHTEST COLOUR FIRST SO THAT YOU WONT HAVE OVERSHADOWING.

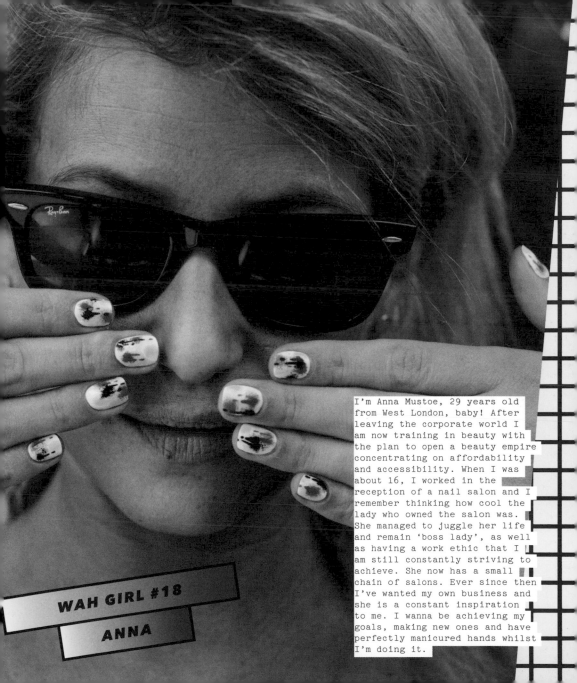

WAH GIRL #18

ANNA

I'm Anna Mustoe, 29 years old from West London, baby! After leaving the corporate world I am now training in beauty with the plan to open a beauty empire concentrating on affordability and accessibility. When I was about 16, I worked in the reception of a nail salon and I remember thinking how cool the lady who owned the salon was. She managed to juggle her life and remain 'boss lady', as well as having a work ethic that I am still constantly striving to achieve. She now has a small chain of salons. Ever since then I've wanted my own business and she is a constant inspiration to me. I wanna be achieving my goals, making new ones and have perfectly manicured hands whilst I'm doing it.

ASTROWIFEY

ASHLEY 'ASTROWIFEY' CROWE, HAS BEEN PAINTING NAILS FOR YEARS IN IN HER HOMETOWN OF CHICAGO. AS WELL AS BEING A DOPE NAIL ARTIST, SHE ALSO LOVES FANZINES AND IS THE BRAINS BEHIND THE FIRST NAIL ART FANZINE, TIPSY. A TOTALLY INDEPENDENT OPERATION, SHE IS A PIONEER FOR BUILDING A NAIL COMMUNITY THROUGH THE HEROIC MEDIUM OF PRINT, IN AN AGE WHEN SO MUCH TENDS TO LIVE ONLINE.

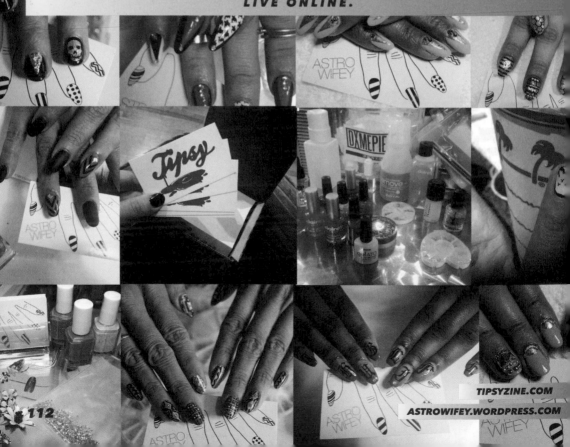

112

TIPSYZINE.COM

ASTROWIFEY.WORDPRESS.COM

TIPSY

When I was around 17 I started to do nail art on myself, just for fun. There wasn't really a nail art community as big as it is now so I didn't think I could make it a career, but I did want to share my work so I started a blog. Seeing all the support in my city about my designs I decided to get educated in nails and start taking clients. Shortly after, I noticed nail art popping up everywhere — on celebrities, blogs, advertisements — and I knew I'd made a good decision.

I went to nail tech school to learn the basics but I learned the most about nail care from other manicurists in the industry. In high school I took an after school painting course, learned painting techniques and used those skills when doing nail art. I've always been into art, drawing and other art mediums.

I set up a nail studio in my home in 2008. I worked as a freelance artist in a salon for a bit, but realised that this sort of setting wasn't for me because of the length of time it took to do one hand-painted nail art — salons want their manicures to be a quick service — so to design nails freely and at my own pace I decided to work from my own studio.

There were struggles to overcome and as Chicago is a big city, sometimes it's hard to get people to pay attention. You have to drill ideas and new concepts in their heads so it started off slower with clients at first, but eventually I was able to keep a steady flow of clientele.

I love doing artist tribute nails, especially artists that I personally enjoy. My favorite sets are inspired by Steve 'Espo' Powers, Basquiat, Andy Warhol, Roy Lichtenstein, Banksy and Camille Rose Garcia. My ideal soundtrack to paint nails to is a mash of Aaliyah, Grimes, Pharcyde, Missy Elliot, Biggie, and Maluca MALA. I do work with a range of clientele so I try to be respectful of what they are listening to, so sometimes I put on neutral sounds like Estelle.

My fave nail artists are Disco Nail, Madeline Poole, Nail Swag, The Illustrated Nail, El Salonsito, and of course the girls at WAH! My craziest design I have done was a set of embedded dollar bills and a baby ultrasound in acrylic! (The ultrasound was a strange request.)

My advice for anyone wanting to get into nails is simple: work hard, practise, and be good to your clients. Social networking is awesome — free advertisement — so take advantage of sharing your work on the web.

We started Tipsy 'zine in November 2012. We are proud to be the first printed nail art magazine in the United States and we love to support all the indie nail artists. Although we are born in the US we do ship worldwide! We wanted to offer a platform to support the nail artists that are doing things in the community. It's awesome to see documentaries, new nail art products, artists, nail art books, clothing and jewellery — it just never ends! We needed a place to collectively find all the flyest nail art news in one spot. The hardest thing about doing a 'zine, I would say, is time management. There are so many deadlines and I can't deny that it gets tough managing my career with AstroWifey along with Tipsy. But it's so much fun and I wouldn't have it any other way. I'm lucky enough to have an amazing small team and my co-editor Isis Nicole who finds all the coolest nail news. For the future of Tipsy, we hope to keep growing and eventually be stocked in most salons and indie retailers. We love that our readers can watch us grow.

Totally inspired by our fave babes in the film *Clueless*, this tartan design looks great on short, square nails. Like most of our designs, it's a whole lot easier if you have an actual swatch of tartan fabric to replicate. Keep practicising those straight lines!

YOU WILL NEED
· red polish
· white striper
· black nail art pen
. black striper
· yellow striper

STEP 1
Paint the nails in a base colour of red.

STEP 2
Using a white striper, paint two lines vertically down the nail and two white lines horizontally across the nail.

TARTAN

STEP 5
Using a black striper, paint a line vertically and horizontally to frame the nail. To make it stand out more, follow the same lines again with a yellow striper.

STEP 4
Continuing with the nail art pen make little diagonal dashes over the rest of the white stripes.

STEP 3
Where the white stripes cross over, paint four little black squares over them using a nail art pen.

TOP TIP
THIS DESIGNS LOOKS AMAZE WITH THE COLOURS FLIPPED! A YELLOW BASE WITH RED LINES

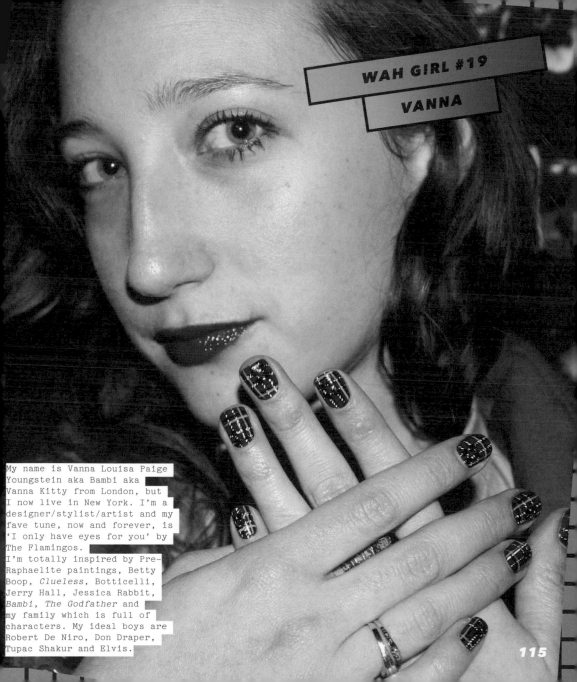

My name is Vanna Louisa Paige Youngstein aka Bambi aka Vanna Kitty from London, but I now live in New York. I'm a designer/stylist/artist and my fave tune, now and forever, is 'I only have eyes for you' by The Flamingos.
I'm totally inspired by Pre-Raphaelite paintings, Betty Boop, *Clueless*, Botticelli, Jerry Hall, Jessica Rabbit, *Bambi*, *The Godfather* and my family which is full of characters. My ideal boys are Robert De Niro, Don Draper, Tupac Shakur and Elvis.

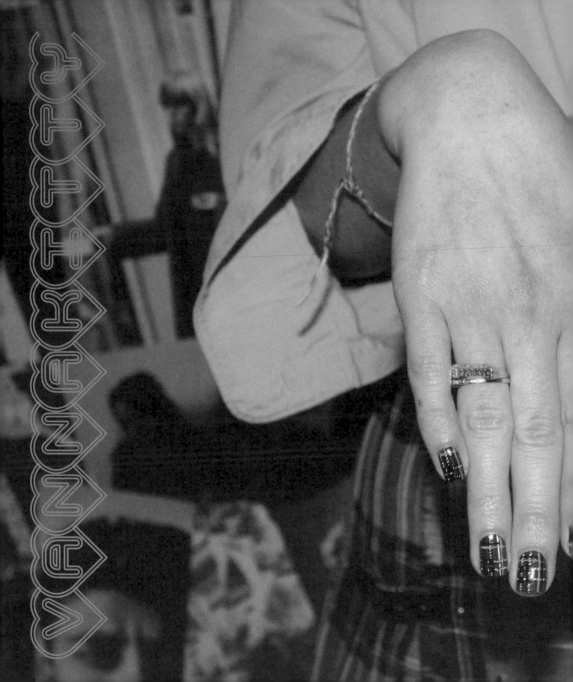

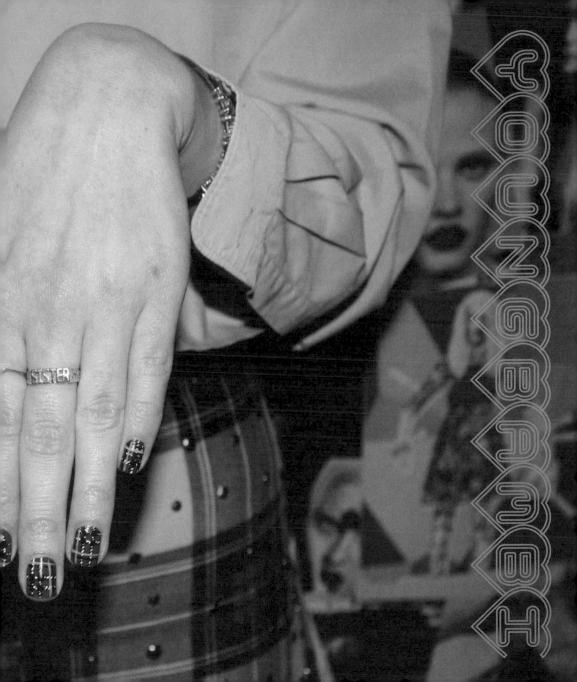

NAILGASM

AYLA 'BRASS' MONTGOMERY WAS THE GIRL RESPONSIBLE FOR THE AMAZING DOCUMENTARY NAILGASM RELEASED IN 2012, FEATURING INTERVIEWS WITH ALL THE DOPEST NAIL ARTISTS IN THE GAME. NOW WITH A YOUTUBE CHANNEL OF THE SAME NAME, WE QUIZZED HER TO FIND OUT HOW SHE WENT ABOUT FUNDING HER OWN FILM AND WHAT SHE LEARNT ALONG THE WAY.

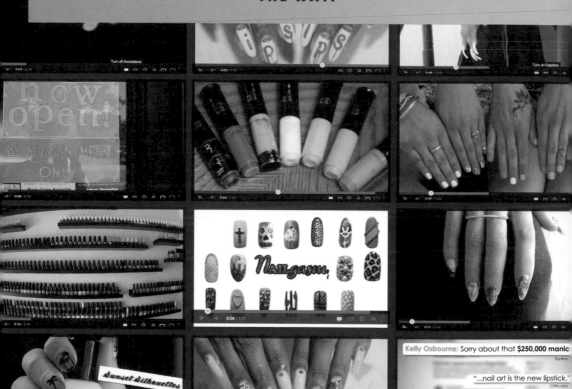

now open!
BY APPOINTMENT ONLY

Sunset Silhouettes
NAIL ART TUTORIAL
BY
Hey, Nice Nails

118

Kelly Osbourne: Sorry about that $250,000 manic

"...nail art is the new lipstick."

"...the fastest growing segment of the beauty tra

"Polish sales are booming. So what's the lur
a high-concept manicure?"

I fell in love with nail art when I joined tumblr back in 2008 and saw WAH and all these other awesome nail art blogs. I saw that it was becoming incredibly popular and I wanted to know why, so I decided to make a film about my findings! Funding came from Kickstarter and my life savings. I've spent them all so please go rent *NAILgasm*! Film wasn't something I'd studied before but I'd been working in television production since 2007, so had some idea of what the process involved. I quit my job a few months after starting the project so that was pretty scary but so far it's all worked out, thankfully! It's taken around a year and a half from the initial idea to becoming a fully finished product, *NAILgasm* was released on 17 December 2012.

The journey to make this film has been incredible. I got to meet so many amazing women all over the world who inspire me by living their passion. But it has also been tough. I've never done anything like this before but when I got the DVD in my hand for the first time, it really felt like a dream come true. I learnt a lot along the way. Tons, infact. Mostly about how to structure a story well and make people excited to see it. I also learnt loads about nails, obviously. I didn't know all of the amazing things you could do to a nail. I had never seen 3D nail art before I started making the film so that was awesome to see how it's done up close. I can't choose a fave nail artist out of the ones I interview for the film. There were so many - Spifster, Naja and Sam Biddle had some really inspiring things to say. What's coming up next? I'll be promoting my film and teaching the world about nail art by working on the youtube channel NAILgasmTV!

What we love about this nail design is that it takes the basic elements of an old nail design 'fade away', and with a little flip and a simple change of colours, you can create something totally relevant and new. This design is all about summer festival vibe!

YOU WILL NEED
· white polish
· yellow pastel polish
· pink pastel polish
· turquoise polish
· blue polish
· purple polish
· sponge

TIE DYE FADE

STEP 1
First paint your nails a white base colour and allow it to dry. This helps the colours you use stay really vibrant and makes them easier to blend.

STEP 2
Then paint the darker of the two colours you're using on one half of the nail.

STEP 3
Using the lighter colour repeat the process on the other side, slightly overlapping the first colour.

STEP 4
Then using a sponge dab the lighter colour you've used, up the middle of the nail, overlapping the darker colour. Keep doing this to build up the gradient effect of the two colours blending.

STEP 5
Repeat the process on each nail using your different colours.

TOP TIP
YOU CAN ALSO USE A PALETTE AND BLEND THE TWO COLOURS BEFORE APPLYING TO THE NAIL, JUST MIX THE COLOURS TOGETHER AND USE THE SPONGE TO DAB ON THE MIDDLE OF THE NAIL.

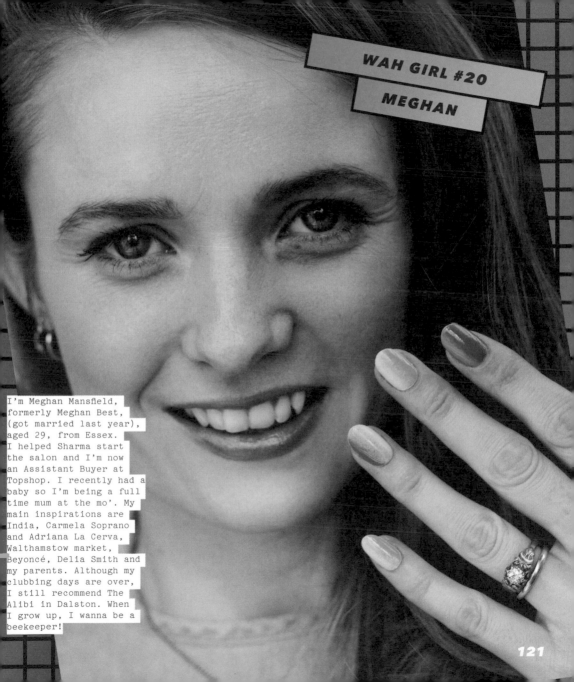

I'm Meghan Mansfield, formerly Meghan Best, (got married last year), aged 29, from Essex. I helped Sharma start the salon and I'm now an Assistant Buyer at Topshop. I recently had a baby so I'm being a full time mum at the mo'. My main inspirations are India, Carmela Soprano and Adriana La Cerva, Walthamstow market, Beyoncé, Delia Smith and my parents. Although my clubbing days are over, I still recommend The Alibi in Dalston. When I grow up, I wanna be a beekeeper!

FLOSS GLOSS

WE LIKE NOTHING MORE THAN A GET-UP-AND-GO ATTITUDE ASWELL AS DOPE NAIL COLOURS. DYNAMIC DUO ARETHA FLOSS AND JANINE LEE 'FLOSS GLOSS BOSS' PROVIDE BOTH. HAVING TEAMED UP AT COLLEGE AND NOW WITH THEIR OWN PRODUCT LINE, FLOSS GLOSS, THEY ARE A PERFECT EXAMPLE OF HOW RELATIVE NOVICES IN THE FIELD CAN SET UP A SUCCESSFUL BUSINESS AND SURPASS EVERYONE'S EXPECTATIONS. WE TALKED TO THE GIRLS ABOUT HOW THEY STARTED OUT, AND THEIR HOPES AND DREAMS FOR THE FUTURE.

JOB INTERVIEW?

A+J: 'Tanlines' or 'BritBrit2000' nude nails - keep it business.

FIRST DATE?

A+J: 'Fastlane','Wavepool' or 'Partybruise' — dudes seem to like red or baby blue. And goth nails are mysterious.

HEY GIRLS! WHATS YOUR BEST POLISH FOR...

DINNER WITH THE GIRLS?

A+J: 'Dimepiece', 'Bikini Coral', 'Perf' or 'Fastlane' or all four at once! Dress to impress!

We'd always been bummed with the colour scene in the nail game, and after college we weren't cool with our food-service jobs and decided to start our own business two years ago. We'd already started a nail crew called 'Floss Gloss' in college, with a group of our friends and flatmates. Aretha would pop over after class ala 'Kimmy Gibler' - of *Full House* - raving and sharing her latest custom colours she'd mixed earlier at school, or at 4am in her apartment. We'd have 'Nail Time' with all my roommates in our flat where we'd paint nails, do a little Nail Art and we'd watch the most recent ep of *America's Next Top Model*. We were always getting mobbed by Art School girls on campus about the colour of our nails or pedi and so we'd send them in the direction of our painting studio, where Aretha would sell them now considered 'Frankenpolish'(a term Instagram just told me about). Either way, Aretha's colours were a total sell out and most of them were colours we'd never seen readily available to our early 20-something selves. That gave us some validation post graduation that we could probably do it and the rest is history. We've been grinding ever since.

How did we do it? After the initial buzz at college, we started to think seriously about turning our hobby into an actual tangible product. It took many, many steps but we basically wrote a business plan and followed it. We made it happen. We didn't and still don't get much sleep, it's a constant hustle. In the beginning there was a lot of researching, phone calling and recon work. We started with manufacturing first, then once we had a rough idea of cost we wrote a lengthy business prospectus. Having not gone to business school and having no formal training in business, writing the business plan was the hardest part, but we persevered because we both believed in our product so much. We finally found funding and started ordering and producing. We made it happen. We cried a lot. But its totally worth it now, we feel so rewarded with every sale and seeing women smile over Floss Gloss.

As always when you're starting your own business, we did have some struggles. We wanted all the colours to be perfect, and sometimes it can be difficult to get exactly right. Formula can be tricky and in the beginning there were a lot rejects. Glitter is always a production from conception to final product. We're constantly pushing our manufacturers, Danzig, with our colour expectations and glitter innovations - we're so lucky they have a relentless attention to detail. Also, like everyone when they start out, we had people telling us we couldn't do it. People were doubtful. They doubted the fact that we, at our age and lack of experience, could pull off something like being entrepreneurs - let alone be at all 'successful' — but we're solely a two-woman-owned and we operated small business in 2013. We're really proud of that.

Our fave nail colours? Aretha always goes for bright orange nails. Right now her favourite is 'Con Limon', a Floss Gloss lime green which really pops. Janine always opts for bright opaque cream and pastel shades. The best nude we've got right now is 'Tanlines' which makes everyone's nails feel and look great. We're really happy that at the moment nails are a great creative outlet for a lot of women, it's great to see the positive effects nail polish can have. Colour is the greatest accessory. Nail painting and nail art are non-commitment acts of art. Nails, like fashion, are an extension of your personality embodied by colour and or art application. It becomes an additional accessory to every look, like a handbag, ring or a good pair of platforms. I think when a woman has a great mani, art or no art, she feels like she's Flossin'! Beauticious self confidence. Hot nails = hot babe!

Our message to other girls just starting out is to get a huge calculator and an espresso maker and sit tight cuz 'it's a long way to the top if you wanna rock and roll'! It may look like fun, but it's a lot of hard work, you've gotta make sacrifices. And also, seriously, you can't fake passion. No matter how hard or long you think it will take you, double it and persevere - you can do it - seriously. You are the only person standing in the way of your ambitions and aspirations. They're waiting for you.

We made this design pretty early on in the salon when we became obsessed with tie-dyeing all of our clothes (we were gonna start a brand called Tie Or Dye! Lol) and wanted nails to match! Oh the things you can do with a cocktail stick! If want to add black into your design it looks amazing and inky.

YOU WILL NEED
- yellow polish
- orange polish
- cocktail stick

TIE DYE SWIRL

STEP 1
Work on one nail at a time and begin by blobbing the yellow nail varnish in a big strip across the base nail.

STEP 2
Leaving a gap in the middle of your nail, dab a thick strip of yellow polish on the tip of the nail.

STEP 3
Working quickly, with your orange polish, blob a large strip across the middle of the nail. overlap with the yellow and you start to see the colours mix.

STEP 4
Using a cocktail or cuticle stick and gently drag the colours into each other in a swirling pattern.

STEP 5
Add more colour if you feel its uneven or lacking and then wait at least ten minutes before applying the topcoat as the nail polish will be thick.

TOP TIP
IF YOU FIND YOU ARE SCRATCHING THE POLISH ALL THE WAY TO THE BASE OF THE NAIL, YOU CAN DO A BASE OF YELLOW AND LET IT DRY.

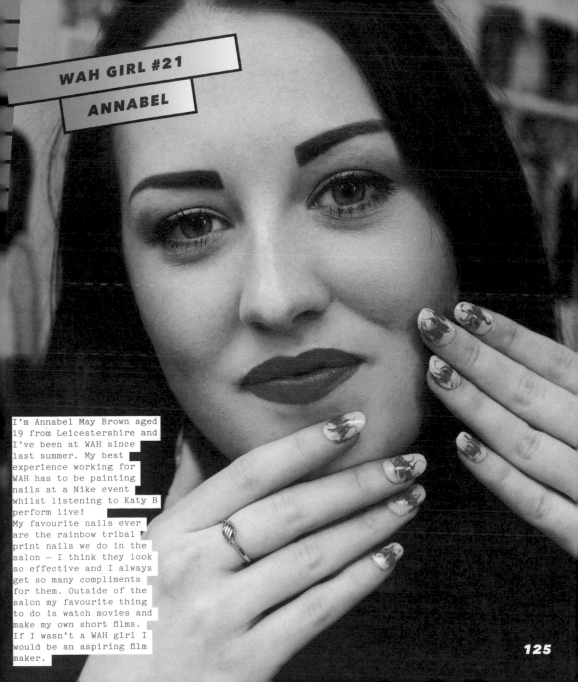

I'm Annabel May Brown aged 19 from Leicestershire and I've been at WAH since last summer. My best experience working for WAH has to be painting nails at a Nike event whilst listening to Katy B perform live!
My favourite nails ever are the rainbow tribal print nails we do in the salon — I think they look so effective and I always get so many compliments for them. Outside of the salon my favourite thing to do is watch movies and make my own short films. If I wasn't a WAH girl I would be an aspiring film maker.

125

BEST FRIENDS 4 EVA!

POWER COMES IN NUMBERS AND EVERY WAH GIRL HAS THEIR CREW TO HELP THEM THROUGH THE GOOD TIMES. AND THE TOUGH. AS MUCH AS WE'RE ALL LOVE OUR INDEPENDENCE, YOU CAN'T ALWAYS DO IT ALONE, AND HAVING A BFF IS SOMETIMES OUR MOST POWERFUL WEAPON OF ALL. YOU NEED SOMEONE WHO GIVES YOU HONEST CRITICISM AND WILL ALWAYS BE THERE FOR YOU NO MATTER WHAT. JEN BRILL AND OLIVIA KIM KNOW THE POWER OF A GOOD FRIENDSHIP AND HAVEN'T LET THE FACT THAT THEY NOW LIVE IN DIFFERENT CITIES GET IN THE WAY OF THEIR MEGA-CUTE AND INSPIRING BFF LIFE.

Let's do a little intro (as if they need it). Jen Brill is one of the original downtown girls and has so many strings to her bow - agent, muse, fashion icon - that it becomes impossible to reel off the impressive list. Let's just say she's been owning it since day dot and continues to kill it. Whilst Olivia Kim, former vice-president of creative at Opening Ceremony (basically part of the original team that made it the awesome multinational store it is today), is one of the nicest, most talented chicks we've come to know in a long time. And they both love nails! We fell in love with their totally adorable pan-America friendship so decided to get the lowndown on the BFF's to chat about friendship rules and what they love about each other.

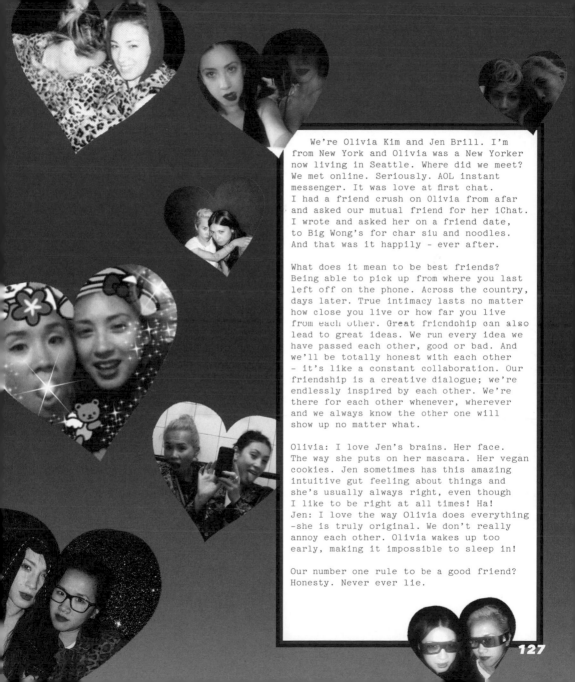

We're Olivia Kim and Jen Brill. I'm from New York and Olivia was a New Yorker now living in Seattle. Where did we meet? We met online. Seriously. AOL instant messenger. It was love at first chat. I had a friend crush on Olivia from afar and asked our mutual friend for her iChat. I wrote and asked her on a friend date, to Big Wong's for char siu and noodles. And that was it happily - ever after.

What does it mean to be best friends? Being able to pick up from where you last left off on the phone. Across the country, days later. True intimacy lasts no matter how close you live or how far you live from each other. Great friendship can also lead to great ideas. We run every idea we have passed each other, good or bad. And we'll be totally honest with each other - it's like a constant collaboration. Our friendship is a creative dialogue; we're endlessly inspired by each other. We're there for each other whenever, wherever and we always know the other one will show up no matter what.

Olivia: I love Jen's brains. Her face. The way she puts on her mascara. Her vegan cookies. Jen sometimes has this amazing intuitive gut feeling about things and she's usually always right, even though I like to be right at all times! Ha!
Jen: I love the way Olivia does everything -she is truly original. We don't really annoy each other. Olivia wakes up too early, making it impossible to sleep in!

Our number one rule to be a good friend? Honesty. Never ever lie.

There is so much to be done with black and white polish and a great monochrome design is woven nails. It may look detailed but once you get a rhythm you can cover each nail in a minute or so, making this a quick and easy design.

YOU WILL NEED
· white polish
· black nail pen

STEP 1
Paint your nails in your white base colour.

STEP 2
Starting in the centre of the nail draw three lines vertically using a nail art pen.

WOVEN

STEP 5
Allow to dry fully before painting your topcoat.

STEP 4
Repeat this column in the same way and fill the nail in the same way with horizontal next to vertical.

STEP 3
Below this, draw three lines horizontally, the same length as the three lines above are wide.

TOP TIP
TAKE IT TO THE NEXT LEVEL BY DOING TWO DIFFERENT COLOURED WEAVES, SO ALL HORIZONTAL LINES ARE ONE COLOUR AND ALL VERTICAL LINES ARE A SECOND COLOUR.

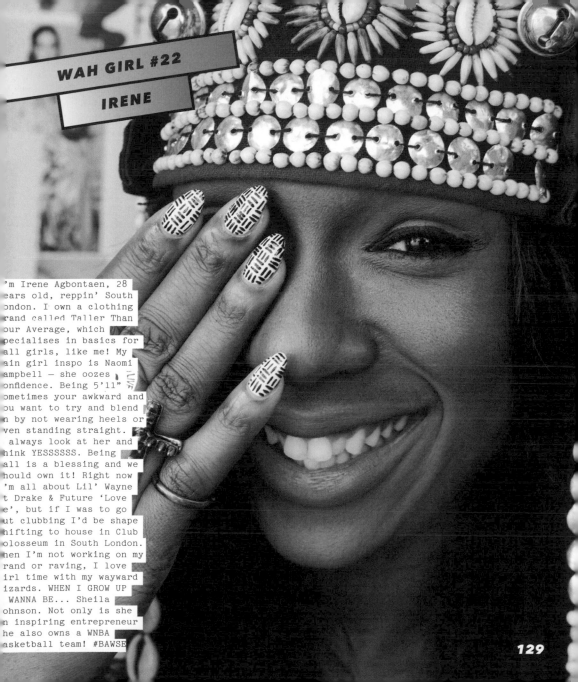

'm Irene Agbontaen, 28
ears old, reppin' South
ondon. I own a clothing
rand called Taller Than
our Average, which
pecialises in basics for
all girls, like me! My
ain girl inspo is Naomi
ampbell — she oozes
onfidence. Being 5'11"
ometimes your awkward and
ou want to try and blend
n by not wearing heels or
ven standing straight.
always look at her and
hink YESSSSSS. Being
all is a blessing and we
hould own it! Right now
'm all about Lil' Wayne
t Drake & Future 'Love
e', but if I was to go
ut clubbing I'd be shape
hifting to house in Club
olosseum in South London.
hen I'm not working on my
rand or raving, I love
irl time with my wayward
izards. WHEN I GROW UP
WANNA BE... Sheila
ohnson. Not only is she
n inspiring entrepreneur
he also owns a WNBA
asketball team! #BAWSE

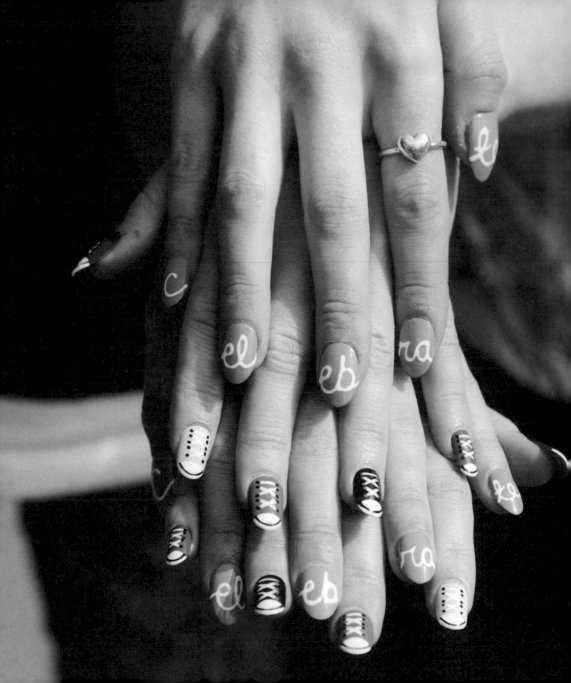

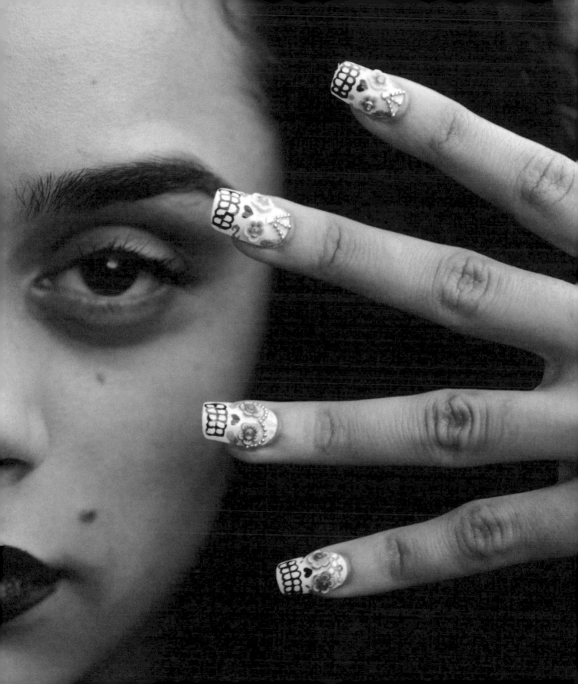

Girls are complex. One minute you love pink hair, the next you hate it; one day you wanna be an artist, the next day you wanna be a financier. Thats why we love the ying and yang design — the idea of two completely opposite forces, complementing each other and forming a whole. Can't decide if you want black or white nails? No worries! Have both colours with this nail design.

STEP 1
Paint all your nails in your white base colour.

STEP 2
Using your black striper draw the ying yang curve. Best way to get the perfect curve is to draw an 'S' shape!

YOU WILL NEED
· white polish
· black striper
· black polish
· black nail art pen
· white nail art pen

YING YANG

STEP 5
Using your white nail art pen, draw a circle on the black side and fill in.

STEP 4
Using your black pen draw a circle on the white side and fill in.

STEP 3
Fill in one side of your 'S' with the black keeping the neatest line on the white side.

TOP TIP
TAKE IT TO THE NEXT LEVEL ONCE YOUVE MASTERED THIS DESIGN DO A CUTE MINI VERSION WITH A BRIGHT NEON BASE!

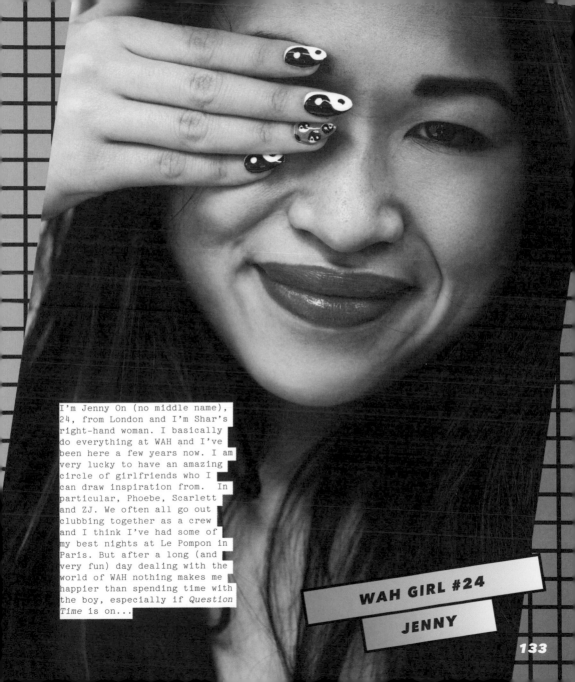

I'm Jenny On (no middle name), 24, from London and I'm Shar's right-hand woman. I basically do everything at WAH and I've been here a few years now. I am very lucky to have an amazing circle of girlfriends who I can draw inspiration from. In particular, Phoebe, Scarlett and ZJ. We often all go out clubbing together as a crew and I think I've had some of my best nights at Le Pompon in Paris. But after a long (and very fun) day dealing with the world of WAH nothing makes me happier than spending time with the boy, especially if *Question Time* is on...

WAH GIRL #24

JENNY

YOON

YOON AND HER PARTNER VERBAL, SET UP AMBUSH DESIGN, OPERATING OUT OF TOKYO, JUST SEVEN YEARS AGO AND ITS NOW ONE OF THE MOST COVETED, AND COPIED, JEWELLERY BRANDS OUT THERE. AS WELL AS BEING A TOTAL MEGABABE, HER SENSE OF FASHION STYLE IS AMAZING, A MIX OF TRIBES THAT ALWAYS END UP LOOKING SUPER SLICK. WITH HER STRONG WORK ETHIC AND CLEAR VISION, SHE WAS ALWAYS GOING TO BE SUCCESSFUL AND HERE HE TELLS WAH ALL ABOUT LIFE AS YOON.

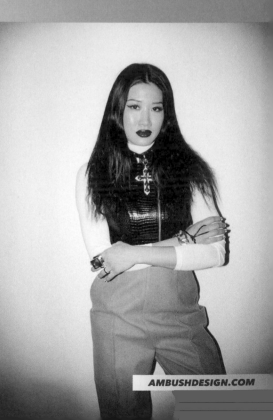

What I love about jewellery is that it's an an instant way to visualise power and make a statement. Verbal and I never trained as jewellers but since we couldn't find what we wanted with jewellery, we started to experiment and make our own custom pieces. That experimenting developed into ANTONIO MURPHY & ASTRO® in 2005. The problem is that it's all made with with 18 carat gold and precious stones, and therefore wasn't accessible to many people. So we started using neon colours, playing around with our infamous trademark 'POW!'™ motif into rings and pendants in alloy metal. It became an instant hit with friends like Kanye and that was became a start of the brother line AMBUSH® in 2008.

The brand mentality for Ambush is ANYTHING GOES. Anything goes in anarchic way. Whatever we believe in, we'll do it our way. We get inspirations from every day things in the street… real subcultures, mass cultures or whatever.

I'm not the type who needs a getway to some remote tropical island to get splashed with ideas. I live in middle of Shibuya the busiest part of Tokyo and the energy that swirls around this town has been the biggest drive and inspirations.

VERBAL is a major label musician and I'm a graphic designer. When formed a company called AMBUSH® DESIGN, everything was DIY. No-one told us how to run things so we had to figure it out

oursleves.During this time, I think people in the industry noticed that we had many ideas and interest in various things so they started to offer us get involved with different projects.

With these many jobs we take on, we learn how things work and we incorporated that into our business. It made sense for us to have an entity and separate company and I believe that if you want creative freedom with what you do, you really have to be more hands-on. To be more hands-on, you have to know how to things work and have to have the understanding of how everything works, you have to learn. Doing outside consultancy work for other brands helps us learn.

Verbal and I are partners for life! Finding love is hard enough but being able to work together AND have fun, its an absolute true blessing!!!

If you have an idea, as with any creative field I say JUST DO IT!!! Really, if you have true vision, start putting it into shape. So many young people these days talk too much. And during this process, don't expect an instant result. It really takes lots of commitment and hard work. And again, stick to your vision! This is so important.

As for AMBUSH®, we are going to launch our new collection called NOMAD at the end of June 2013. We also have AMAZING collabs coming up with this year. Besides that we wanna expand more internationally.

We wanna AMBUSH everyone!!!

Inspired by the incredible Italian brand, Missoni, these tropical zig-zags look amazing with bright backgrounds or a coloured fade. Whether you use the striper or the nail pen is totally up to you! Figure out what tool you can manage the best, but if it is your striper, ensure that you have no loose bristle or they'll ruin your perfect lines.

STEP 1
Paint your base colour on all your nails and using your highlight colour, paint onto your sponge and dab a few spots over the nail.

YOU WILL NEED
· pink polish
· orange polish
· blue polish
· green polish
· black striper or nail art pen
· sponge

ZIG-ZAG

STEP 2
Start in the centre of the nail and paint one zig-zag in the middle of the nail to start you off.

STEP 5
Repeat zig-zag lines all the way to the tip of your nail.

STEP 4
Using your first line as a guide, repeat zig-zag lines towards the base of your nails.

STEP 3
Complete the zig-zag to the left and right to create one long zig-zag going across centre of the nail.

TOP TIP
MAKE YOUR ZIG-ZAG LINES GET SMALLER AS THEY REACH THE BASE AND TIP OF THE NAIL FOR AN OPTICAL ILLUSION EFFECT!

136

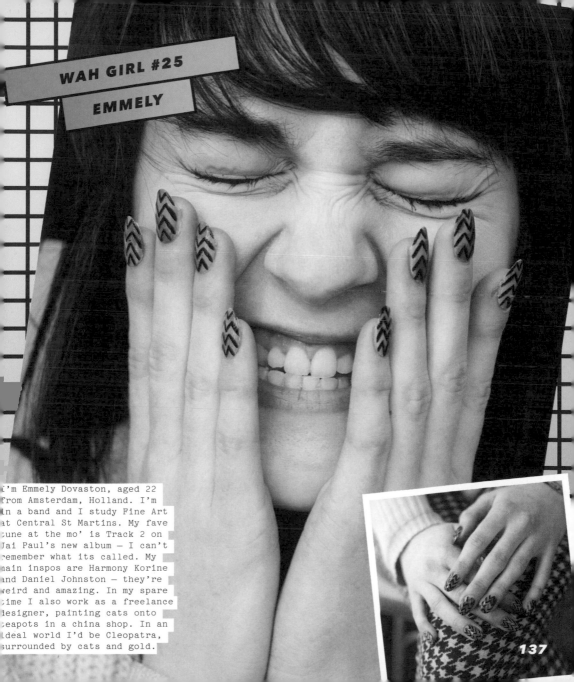

I'm Emmely Dovaston, aged 22 from Amsterdam, Holland. I'm in a band and I study Fine Art at Central St Martins. My fave tune at the mo' is Track 2 on Jai Paul's new album — I can't remember what its called. My main inspos are Harmony Korine and Daniel Johnston — they're weird and amazing. In my spare time I also work as a freelance designer, painting cats onto teapots in a china shop. In an ideal world I'd be Cleopatra, surrounded by cats and gold.

137

WAH CREW

STARTED FROM THE BOTTOM NOW MY WHOLE TEAM'S HERE! INTRODUCING THE WAH CREW... OPERATING STRAIGHT OUTTA LONDON THEY'RE THE ULTIMATE BABES THAT KEEP THE COGS OF THE BUSINESS TURNING BY BEING HERE TO PROVIDE THE WORLD WITH CUPS OF TEA, GOSSIP AND OF COURSE, HAPPY NAILS!

SHARMADEAN REID

JENNY ON

CHAR ROBERTS

RAE ELLIMAN

KAT FITZAKERLY

IRENE AGBONTAEN

ELLIE HARRY

LUISA LE VOGUER

LOUIE JONES

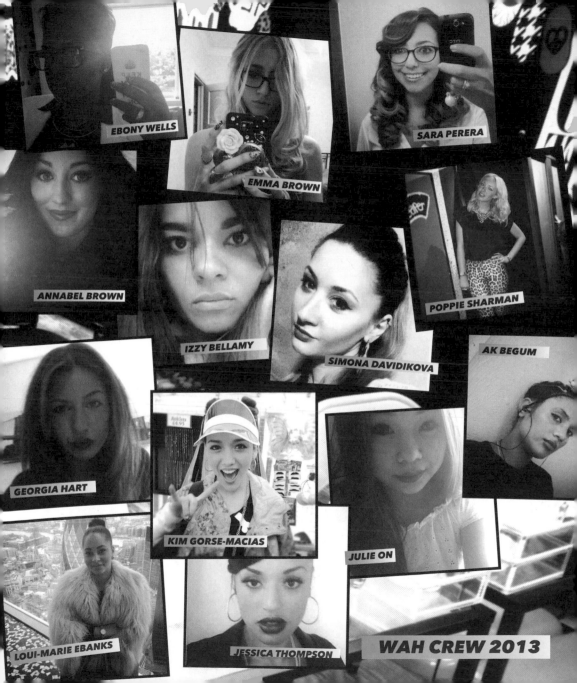

#NAILINSPO

THANKS THANKS THANKS

Its been incredibly exciting to have some new people enter the WAH fold in the last year but my first thanks are to those who have been there from the beginning. Of course my main girl Jenny On, who is so important to me. The salon would not even function if she didnt exist and she totes is the 'Mama Bear' to all the nail techs. Grace, Irene, Suz, Hazel and Phoebe — still my girl crew and still tough to the core! Thanks for listening to my ramblings and musings and supporting the WAH cause. Our superstar intern-turned-employee Ellie, has been indispensable! We love her and owe her so much! To my mega mini-mes Charlotte and Rae. Always there, crop tops and puffas jackets in tow, ready to work. Special thanks to Irene who's been running tings in Topshop and keeping everyone in check! Thanks to the amazing nail technicians whose work has filled this book — they are the ones on the frontline painting nails for our lovely clients every day and keeping us relevant with their new ideas. My gratitude to all the girls featured in this book! The International Nail Crew is strong. Well done for supporting each other and pushing things forward. Without competition there would be no progression. Thanks to Ben and Rory at The New World Projects for designing the book, everyone at Hardie Grant for believing in a second book and to the little most important thing: my baby Roman, for not moaning when Mummy's at her computer working! Love you always!

The WAH Nails Book of Downtown Girls

First published in 2013 by Hardie Grant Books

Hardie Grant Books (UK)
Dudley House, North Suite
34–35 Southampton Street
London WC2E 7HF
www.hardiegrant.co.uk

Hardie Grant Books (Australia)
Ground Floor, Building 1
658 Church Street
Melbourne, VIC 3121
www.hardiegrant.com.au

British Library Cataloguing-in-Publication Data. A catalogue record
for this book is available from the British Library.

ISBN 978-1-74270-591-0

Commissioning Editor: Kate Pollard
Desk Editor: Kajal Mistry
Editorial Assistant: Charlotte Roberts

Art Direction: Sharmadean Reid
Design: The New World Projects
Design Assistant: Ellie Harry

Nails by: Kim Gorse-Macias, Simona Davidikova, Ellie Harry,Poppie
Sharman, Julie On, Jessica Thompson, Izzy Bellamy, Kat Fitzakerly,
Louie-Marie Ebanks, Sharmadean Reid, Georgia Hart, Annabel Brown

Photographs © Robinson Barbosa and Jeff Hahn.
Additional Photographs © Simon Hurlstone Archer, Finchittida Finch,
Ellie Harry, Bella Howard, Sam Bayliss-Ibram, Erika Miyagiwa,
Amelia Sechman, Poppie Sharman, Sunny Shokrae, Sharmadean Reid,
Charlotte Roberts. Every attempt has been made to contact the
copyright holders. The publishers would like to be contacted
by any photographers who have not been attributed.

Colour Reproduction by p2D

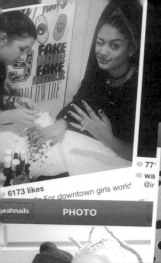

6173 likes
For downtown girls world!

wahnails PHOTO

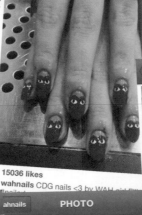

15036 likes
wahnails CDG nails <3 by WAH girl

413 likes
ahnails Skater and @palaceskateboards
ew member Louie wants to join the All Girl

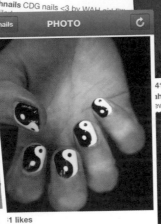

4012 likes
wahnails THE TALENTED @Jessie
WAH'D OUT WITH GLITTER

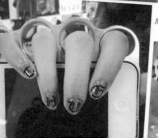

3724 likes
wahnails GOOGLY EYES BY WAH GU
HELLS #nails #nailart

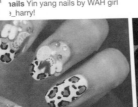

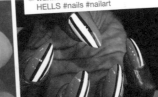

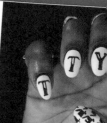